HELMUT NEWTON

SELECTIONS FROM HIS PHOTOGRAPHIC WORK

Edited by Zdeněk Felix
With ~~texts~~ ~~by~~ Noemi Smolik and **Urs Stahel**

Schirmer Art Books

Published to accompany the exhibition
"Helmut Newton – Aus dem photographischen Werk", presented
in the Deichtorhallen Hamburg (26 November 1993 – 23 January 1994),
the Josef Albers Museum, Bottrop (6 March – 15 May 1994),
the Fotomuseum Winterthur (10 June – 21 August 1994),
and in Castello di Rivoli, Turin (October – December 1994).

Exhibition curator:
Zdenek Felix

Exhibition assistants:
Angelika Leu, Hamburg
Véronique Noé, Monte Carlo
Priska Pasquer, Cologne

With the assistance of the Condé Nast Verlag, Munich.

Contributors:
Helmut Newton, Monte Carlo
Rheinisches Landesmuseum, Bonn
Galerie Rudolf Kicken, Cologne

Translated from the German by Paul Kremmel

Schirmer Art Books is an imprint of Schirmer/Mosel Verlag GmbH, Munich
For trade information please contact:
Schirmer Art Books, 112 Sydney Road, Muswell Hill, London N10 2RN, England
or Schirmer/Mosel Verlag, P.O. Box 401723, 80717 München, Germany
Fax 0 89/33 86 95

A CIP catalogue record for this book is available from the British Library.

Reproduction: O.R.T. Kirchner GmbH, Berlin
Typesetting: Biering, Munich
Printing and binding: EBS, Verona
ISBN 3-88814-636-4

Art direction: June Newton
A Schirmer/Mosel Production

HELMUT NEWTON

SELECTIONS FROM HIS PHOTOGRAPHIC WORK

Contents

Overcoming the Other

NOEMI SMOLIK

In the concrete aspect of the world, the face is abstract, or nude.
It is denuded of its own image.
It is the nudity of the face that makes nudity
possible in the world at all.

Emmanuel Lévinas, *En découvrant l'existence avec Husserl et Heidegger*, Paris 1974

HELMUT NEWTON is not a conventional fashion photographer. Leafing through any of his books – *White Women* (1976, his first publication), *Sleepless Nights* (1976) or *Big Nudes* (1982) – makes this obvious. Although several of the photos in these books were also printed in glossy fashion magazines, they are still not fashion photography. Even when the women wear fashionable clothes in the pictures, the photos are more than mere fashion shots, since they possess a timeless quality that at first seems inexplicable.

The women in Newton's photos are mostly placed in settings that transcend the present and its impermanence; they assert their own existence in defiance of time. Newton's women appear in ancient, half-decayed Italian gardens in which time seems long since to have stood still, they appear before grandiose entrances and in elaborately furnished rooms in fine, turn-of-the-century hotels, or they stand in elegantly furnished flats of the Parisian *haute bourgeoisie*, who cling to traditional luxury and stability, similarly withdrawn from the relentless pulse of time.

Newton's women also wear clothes, undergarments and shoes that cannot be assigned to any particular trend in fashion. In fact, the photographer is not at all interested in clothing. The clothes are not objects in themselves as for most fashion photographers. They only have one purpose: to insufficiently conceal the long, slender female bodies with full breasts, smooth backs, ruffled pubic hair, long thighs,

and well-formed bottoms. The dresses, blouses and skirts are constantly falling open, revealing nipples, thighs, pubic hair or the roundness of ample buttocks. And the slender female bodies are repeatedly shown rising from their high-heeled shoes like long flower stalks. They are accompanied, not by modish objects, but by the timeless refinement of fur coats, English saddles, luxurious limousines or baroque chairs.

The female bodies in Newton's photos lack innocence and are hence not classical expressions of beauty. A slight trace of the disreputable, which makes the slender, often athletic bodies appear somewhat dissipated, glistens on the exposed, bare skin. The bodies are enveloped less by clothes than by a sexual tension, which, as in baroque nudes, often seen in the background of Newton's photos, has a rapt quality of permanence. The women in Newton's photos withdraw their bodies and the sexuality that envelops them from the flow of time. And a photo with timelessness at its core is not a fashion photo, since the driving force of fashion is the inexorable march of time and the constant change it brings. Timelessness is the nemesis of everything fashionable.

In Newton's photos the women appear in various poses: reclining, with spread legs, graciously seated in comfortable chairs, squatting, running, leaning to the side or out of a window and standing. They are clothed, barely clothed, or often completely nude. Thus, at first glance, the photographs seem quite disparate. But after repeatedly leafing through Newton's early books, the images in the photos begin to form a unity, a common theme, which becomes all the more apparent the more one looks at them. With an almost merciless insistence, admirable intransigence and an almost obsessive perseverance, all these pictures focus on one and the same thing: the exposed female form, the nude as event. The portrayal of the naked female body is in itself an event of almost traumatic proportions.

It is precisely this event that takes place in the large photos that display the completely nude, female bodies, whether walking or standing on high heels. But unclothed also means unprotected. Thus, the nudity of these female bodies also expresses their peril. A peril that with brutal directness reveals the profound inscrutability of human nature. Humbled by their nudity and yet transcendent, braving the vor-

tex of the inscrutable with their appearance, these bare legs, breasts and shoulders stand defiant with an immediacy aimed directly at the viewer. For a brief moment a deep chasm opens up, and what is glimpsed in the dark depths below leaves us trembling.

Afterwards, we are never the same. Newton's big nudes have such an unsettling, provocative and threatening effect because the confrontation with such figures always has an unusual, jolting, even excessive aspect. The nudes always go beyond the borders beyond which the dark depths of the chasm open up, they always go one step too far, they always move along the edge of the abyss, they have a criminal air. Most of the unclad women in Newton's photos are in motion, and often they are perpetrators of a scarcely definable crime, whose victims are men and women alike.

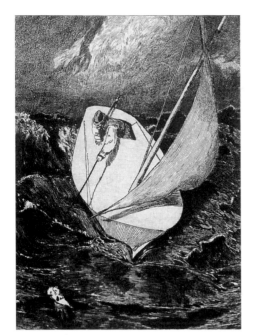

Max Klinger: *Rettung* from the series "Der Handschuh", etching, 1978–81

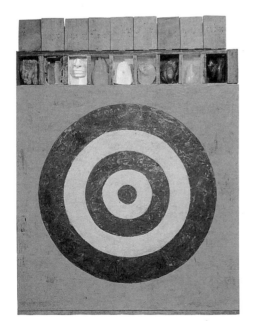

Jasper Johns: *Target with Plaster Casts*, 1955. Encaustic and collage on canvas with objects. Castelli Collection, New York

The desirable does not gratify my desire,
but deepens it,
feeding me, as it were, with fresh hungers.

Emmanuel Lévinas, *En découvrant l'existence avec Husserl et Heidegger*, Paris 1974

FEMALE nudes are the ever-recurring motif in Newton's photographs. Even when he portrays such celebrities as Paloma Picasso, whom he shows with bare bosom, or the model Veruschka, whose open robe reveals her pubic hair, he transforms them into nudes. This transformation has a ritual aspect, not only as an act Newton repeats but also as an act governed by a particular pattern. In these photos, everything is precisely staged, everything is under control. The folds of the clothing and their openings, the curve of the breast detectable under the fabric, the bare thighs, the exposed underarm hair, the shoes, worn or unworn, nothing has been left to chance, nothing is accidental, everything follows a pattern, a ritual pattern. But what is ritual?

Ritual action is directed against any kind of threat that causes unbearable anxiety. Death, pain, the opposite sex and hence also everything sexual and ecstatic are threats of this sort, which since time immemorial have caused unendurable fear, and which still alarm us today. To contend with this unbearable anxiety, ritual acts are conceived to counter the threat. Even today when people feel threatened, they begin to arrange the objects around them, to perform certain actions and to repeat these at regular intervals.

People begin to give their lives a ritual form, to banish the threat by the performance of an action, to create between themselves and the threat a distance that keeps the anxiety within endurable bounds. Thus all ritual is an attempt to ward off. And what is to be warded off is a threat that approaches fatal proportions. Accordingly, Newton's nude photographs could be viewed as a repeated attempt to ward off danger. But what kind of danger or threat are these photos intended to banish?

The slender female bodies in Newton's photos are cloaked in costly furs, their round, full breasts shrouded in silk garments and black lace, their long legs in fine, diaphanous stockings, and regardless of

whether they are clothed, half dressed or completely naked, they typically wear high-heeled shoes of timeless elegance. It is precisely these high-heeled shoes that are so characteristic of Newton's photos. But a closer look at the furs, smooth silk undergarments, sophisticated lace, and diaphanous stockings, and at the high-heeled shoes in particular, reveals that these are all objects with a strongly fetishistic character.

Fetishes never appear accidentally, and their appearance is never without meaning. They explain, or rather divulge, something wherever they appear. They are tracks, pursuing which means entering hidden chasms, confronting sex, death and crime. For this reason as well, the women clad in lace, furs and high heels in Newton's pictures are primarily harbingers of the unfathomable.

Fetishes are objects that are also used during the sexual act. But they can also become independent and attract sexual desire apart from the act itself. Women's undergarments, silk stockings, furs, soft fabrics, gloves and shoes can become fetishes, with one of the most widespread fetishes being the shoe. Such objects are used as substitutes, and the essential feature of a fetish is its ritual use. Fetishes most often develop into rituals.

In this case the fetish is not necessarily part of a sexual act. It can assume the function of an amulet, a magic object that becomes a symbol within a religious ritual, or function as a memento of an unfulfilled romance. And it can be part of an artistic act. The fur coat, the see-through underwear, the stockings, but also the whips, the saddles and the ever-recurring high heels are autonomous fetishes of this sort, signifying sexual desire.

They shroud the bare skin of the smooth, female body, their fetish character endowing it with a seemingly immutable character. This is also why the female bodies in Newton's photos, wearing high heels, furs, silk and lace arouse a desire that is immune to time. Their bodies seem removed from cruel transience, decay and death, since desire is directed to them via the timeless fetish objects.

The need for a fetish arises mostly in situations that threaten our independence and individuality and thus arouse anxiety. In these situations the fetish takes on a saving function, helping to control paralysing anxiety and to preserve independence. This process is exem-

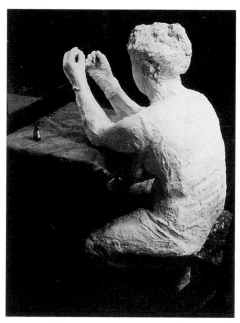

George Segal: *Woman Painting her Fingernails*, 1961

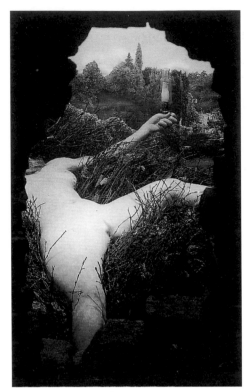

Marcel Duchamp: *Etant donnés: 1. La chute d'eau, 2. Le gaz d'éclairage*, 1946–66, installation, Philadelphia Museum of Art

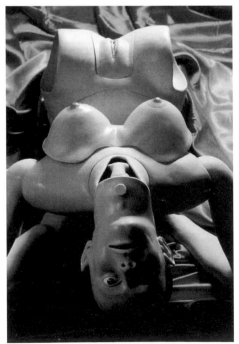

Cindy Sherman: *Untitled # 261*, 1992

plified in twentieth-century art, which has experienced an unparalleled fetishization. This is not surprising, since never before have people been exposed to so many threatening situations, never has their independence been so jeopardized, without recourse to the solace of tradition.

Hence, the fetish has become an essential feature of modern art. We recall Max Klinger's gloves, Marcel Duchamp's urinal and his *Etant donnés* in the Philadelphia Museum of Art, the objects of the Surrealists, the Americans Jasper Johns and Robert Rauschenberg and the many fetish objects of centemporary art: Jeff Koons's plastic hare recast in stainless steel, Cindy Sherman's photographs of dolls, Rosemarie Trockel's black socks and also the high-heeled shoes in Helmut Newton's photos.

The fetish in contemporary art has the task of channelling the anxiety springing up all around us and creating a healing distance between us and it. Thus, the fetish objects employed in art always seem to follow a preordained pattern, which Newton has carried to the pinnacle of perfection in his work. The distance that the fetish objects in his photos create between us and the bared female bodies allows no anxiety, even though it is anxiety that has created this distance.

In his photographs, Newton often shows his women together with life-like mannequins. At first glance, we can hardly distinguish the two. The plastic bodies resemble the real women. Newton ensures that they look real, including pubic and underarm hair. He photographs them embracing the real women, kissing them, reclining on a bed. Here as well, ritual actions are performed in front of the camera. These actions are of unconcealed sexuality, but here too the distancing from the act displayed is so great that an emotionally charged tension hardly arises.

Dolls, mannequins, or any artificial objects patterned after the human body all belong to the magic world of fetishes. Moving between death and life, reality and illusion, mechanical movement and emotionally conditioned reactions, they are hybrid creatures that lead us to a wonderful and yet mysterious world beyond all laws. Here, everything is allowed, here there is neither guilt nor innocence, no wrongdoing, no female or male sexuality, no differences and no anxiety.

It is thus understandable why artists in our century have always been attracted by this magical-hybrid but seemingly so free world. Parts of this world beyond law and guilt are the already-mentioned nude with spread legs in Marcel Duchamp's *Etant donnés*, the effigies by Edward Kienholz, the life-size, morbid figures by George Segal, the obscene dolls by Hans Bellmer, and also the exact human replicas by Duane Hanson and John de Andrea. To this group belong also the photographs with mannequins by Helmut Newton.

Is there a significance in signification
that would not be equivalent to transmuting
the Other into the Same?

Emmanuel Lévinas, *En découvrant l'existence avec Husserl et Heidegger*, Paris 1974

IT is not the task of a fetish, along with ritual action, to keep anxiety at a manageable distance; as with the mannequin, it is always also an attempt to overcome the other. Fetishes are bisexual. Where they are employed, there is always a desire to negate the sexually other. This use of fetishes is found in the art of Marcel Duchamp, in which the fetish, as in the photo *Rrose Sélavy on the Rue Surréaliste*, accompanies a change of sex, and they can always be found where the human body – as so often in contemporary art – is dissected, transformed, raped or mistreated in order to subdue the otherness of the other sex.

Newton's photographs are different. In his photos the fetish, employed ritualistically, does banish anxiety, but it does not transform the female body. In contrast to much of the output of contemporary art and photography, Newton dares to show the female body in its threatening otherness and challenging independence. Nothing can subdue these bodies, nothing can banish the threat they pose. Nor can their otherness be extinguished by any sacrifice. The male as well as female sacrifices in these photos always prove to be ineffective. Thus, Newton's photos testify to the painful fact that in spite of every attempt, despite every ritual transformation and every sacrifice, a unification that eradicates the contradiction between the sexes and the anxiety this leads to is only an illusion. "My women are always victorious", Helmut Newton has stated in an interview. In their otherness, we must add.

Participating without Consequences

Rules and Patterns of Newton's Voyeurism

URS STAHEL

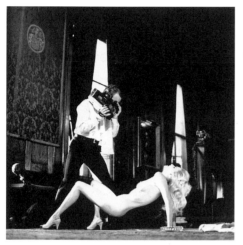

Study for "Voyeurism", Los Angeles 1989

THE setting seems to visualize a leap backward in time; the stage is a darkened palace room with high ceilings and tall windows. Silk tapestries on the wall with ornamental patterns, heavy curtains slightly opened to give an almost theatrical lighting effect, richly ornamented wood furniture, the traditional portrait in oils and a wooden sideboard create an impression of the *ancien régime*, highlighting, as it seems, a journey back into France's glorious past. In the foreground, in contrast, a less elegant but very contemporary performance: a man filming a woman. Concentrating, he leans toward the woman who is stretched out in front of his camera, supporting herself with her arms in an apparently strenuous pose. He is dressed, probably too warm with the scarf around his neck; she is nude, a blanched, scorched nudity from the strong light on her body. He is filming, she is exhibiting herself and being observed. The complementarity of their actions is expressed in the mutual triangles formed by their thighs. Their legs seem to emerge from the same black-and-white stiletto-heeled shoes. Also, the streaking of his severely combed-back hair is picked up in her long, flowing mane and in the tassels of his scarf, while the waves of her hair are matched by the way the scarf hangs. The two seem bonded together like Siamese twins, even if only during this mutual act of reciprocal seeing and presenting. A depiction of the complementarity of voyeurism and exhibitionism.

"Ensayo sobre 'Voyeurisme', Los Angeles 1989" is the caption in the Spanish catalogue.[1] The explicit theme of the photograph is voyeurism, a practical and theoretical study of a principle which, strictly understood, applies to photography as a whole, even though much more clearly expressed in the work of Helmut Newton than elsewhere.

It is a Newton photograph with all the elements of his pictures, but here he has obviously chosen to reflect or explicate his own work.

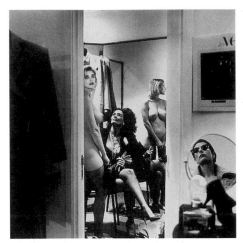

Study for "Voyeurism", Los Angeles 1989

Originally taken for *Playboy*, a bulwark of voyeurism, its manner of execution makes it completely unclear whether the display was meant for private pleasure or commercial exhibition, whether it took place voluntarily or under coercion. It has all the comments and complexity that Newton treasures – disjunctions, discrepancies, the functional uncertainties he must love, since this is what lends his pictures their enigmatic presence. But the gap we mentioned at the start, the leap back in time, is neutralized again by the subtitle: Los Angeles 1989. The voyeuristic desire and exhibitionistic willingness shown are therefore not much younger than the velvet of the curtains. In the realm of images, every chateau, no matter how real, instantly appears as a backdrop, as staffage – built up exclusively for the self-rejuvenating word of "prime-time" images.

The following two pictures in the catalogue have the same title. At first glance, one looks more innocent, but also more inscrutable, more complex. We see two rooms; through an anteroom and a half-opened door, we look into a dressing room with ceiling-high mirrors. Two women and their reflections in the mirror, and the mirrored face of a third woman, are the actors, along with a hanging raincoat, scattered clothes, stockings and accessories. A curvaceous young model, naked except for stockings and shoes, who has turned toward the door, a bit surprised and frightened, is evidently looking at the intruding third woman; a somewhat older, opulent, enticingly dressed woman is seated and is gazing – through a monocle, as it seems – at the young woman (or her attractions); and the third woman, whom the observer sees as part of a strange, unfocused still-life in a round dressing or shaving mirror, has an androgynous or even male appearance with her combed-back dark hair, dark sunglasses and raincoat. She reminds one of a detective or peeping-tom. Three female types, three generations perhaps: innocent youth, the wise, tutoring and craving woman, and the figure whose gaze is hidden and who is perhaps playing a masculine role. It seems to be an educational piece, an exercise in seeing, being seen and showing oneself. Education in the dressing room. The framed *Vogue* print on the wall is purposefully cropped off after the letters VO and may now be read as the beginning of "voyeurism".

A third example of a reflective Helmut Newton is a closeup with a

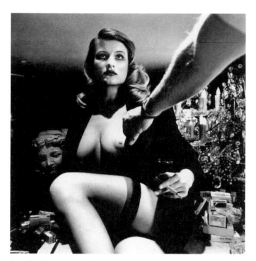

Study for "Voyeurism", Los Angeles 1989

very forceful effect (see also Plate 74). At closer distance than usual, only an arm's length from the lens, another well-built young woman is posing. Her gaze, with a trace of reverie, is directed above and beyond the camera, apparently at the face of man whose presence is seen in his intervening arm. Her dress is half open and is being draped by the man to expose one breast. Her posture is somewhat unresolved. Leaning back slightly with crossed, almost closed legs, she has a hesitantly defensive look; her gaze and her breast, however – the bare breast forms the centre of the square-shaped picture – and the top of her stockings invite our scrutiny. In addition to several sexual references, allusions and symbols, such as the chandelier, which can be construed as a phallic Christmas tree with its artificial candles, and the dozens of film boxes like unpacked presents, which together with the half-opened dress offer a field day to voyeurs, the picture is constructed in such a way that the observer looks at it from the point at which both the camera and genitals of the invisible man are located. In no other known photograph by Newton is the voyeuristic gaze so closely connected to the act of photographing and the male genitals. Her eyes are on the face of the intruding male, while our gaze is first at the central breast and then moves up or down. The act of looking is explicitly understood as sexual: "*Le regard est l'érection de l'œil*" (Jean Clair). The various film boxes – TMAX, Kodacolor, Ektachrome, Fuji, etc. – the complete palette of colour and black-and-white, of fast or grainy film material illustrates the construction, over-loading it with quantity. Conspicuous is also the man's arm, which, with a wristwatch, crosses the picture diagonally, pointing beyond the breast to a stone female bust, so as to appeal to tranquillity in the midst of our hectic pace, reminding us of eternity amidst the here-and-now, of the unchanging, the archetypal female in the presence of this immaterial beauty who appears as a photographic product, perhaps as thin as the paper.

These three photographs from his "late period" are not the first to address voyeurism, but the inclusion of this theme in the captions was probably never so explicit before. Newton, who often in response to questions said he was a voyeur and that a photographer who didn't admit this was an idiot,[2] Newton the mover and shaker who has always smiled at theorizing, has set up here, not without pleasure,

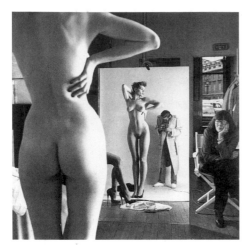

Self-portrait with June and Models,
Vogue studio, Paris 1981

his own benchmark, has established a theoretical/thematic retrospective. His œuvre is full of autobiographically tinged photographs. Whereas some of these pictures fall into the category of frivolous self-portrayals, other photographs, such as the famous *Self-portrait with June and Models* and *Valentino Place, Los Angeles 1987,* are serious efforts at self-reflection. Victor Burgin, in his essay "Espace pervers",[3] placed the *Self-portrait* at the beginning of his discussion, emphasizing the complexity of the pictorial construction, the additive repetitions, chiasmus-like exchanges and crossings on the descriptive and the connotative levels.

Here, Helmut Newton has created a surfeit of mutually complementing and contradictory pictorial elements: Newton is dressed, even overdressed in a raincoat, white tennis shoes, and with a twin-lens Rollei; the model with her back toward us and reflected in the mirror is naked except for her black high heels; besides the two standing figures are the two seated minor figures: June, his wife, clothed, with crossed legs, and a hidden model, of whom only the bare legs and black stiletto heels are visible; tossed to the floor, as so often, are a light blouse on a dark background and a dark blouse against white. Two figures are busy, in motion, the other two waiting, somewhat bored. The standing model emphasizes her stretched position with the "pin-up pirouette"[4] of her arm and hands, in contrast to June, who is holding her head somewhat listlessly, her arm resting on her knee. Newton, the man behind the camera, stands invisibly in the viewer's position: in the limelight of the action, in the realm of the model. He is presenting himself in his capacity as a photographer, as an onlooker, in the ambivalence of voyeur and exhibitionist, as a "subject caught up in his own wishes or image."[5] Inside – in the picture within the picture – everything is mirroring and reflection, outside – where June sits in a director's chair – there is transparency, permeability, *sortie,* or an escape from the nexus of signs and their reflections. Victor Burgin interprets this scene, along with Laura Mulvey, not only as voyeurism but as an identification with the object of desire, as objectification, fetishization.[6] The model has become a stiffened figure, an alabaster statue: solidified desire, externalized phallus.

Valentino Place, Los Angeles 1987, viewed by Serge Tisseron in analogy to Manet as Newton's *Olympia,*[7] merits a final close examina-

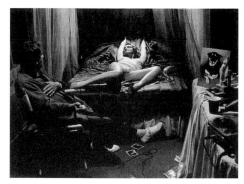

Valentino Place, Los Angeles 1987

tion. Placed in the background in terms of the perspective, in the upper portion of the picture and yet at the centre of attention, a woman is lying stretched out on a quilted batiste bedspread. Her position is emphasized by several elements: wavy tulle curtains frame the elevated bed, helping to create the impression of a stage detached from the foreground (the auditorium), bathed in an almost celestial light from above. Unusually for Newton, the woman seems to be stretching, dissolving her-self, losing herself in physical lust, in her own desire. Her skirt has slid up to the tops of her thighs. Newton himself sits in the left foreground like a theatre spectator observing his starlet (his projection) on the stage, also stretched out, but casual and not noticeably aroused. The symmetry is perfected by a make-up table on the right, with paper cup, tape recorder, books, a satin dress, the picture of a dog sitting and a mass-produced sculpture of a panegyric female figure. The sculpture creates an analogy to the stretched-out woman, the dog to the seated Newton. Newton is observing, with one hand on his chest and the other on a cable release. He appears hardly moved, only she seems to be in the process of dissolution: discarded polaroids on the floor and the telephone next to her on the bed secularize and commercialize the setting, transforming possible intimacy into public exposure. The idealization takes place only on the make-up table and is expressed in the form of kitsch.

These five examples, although exaggerated, show Newton, the fashion, erotic and portrait photographer, although he constantly mingles these genres, to be a reflective photographic artist. Five examples on the theme of voyeurism, which themselves contain little of the seductive force that would automatically turn the viewer into a voyeur. The object of desire has already been claimed: since someone is already looking, a stand-in assuming the role of voyeur in the picture, the observer sees him and the scene itself as a closed entity, sees his gaze and desire, and experiences himself as one reflecting from a distance.

Helmut Newton is a man of action, not indecision. The classical "Newtons" accent the power of seductive play, arouse curiosity, stimulate slumbering desire (certainly in male and probably also in female observers). Developing tendencies are identifiable, both in the style

19

of his voyeurism – from the well-known form of distanced, sharing-without-participating viewing to intervention, when in the age of polaroids and video visual desire becomes the experience of the evening, the theme of subjects of a scene – as well as in the style in which the models, the women, present themselves to "devouring" eyes, the way in which the relation between distance and proximity, warmth and cold, openess and closedness, shifts. Nevertheless, for the moment we shall stick to the general concept of the "classical Newton".

At an initial level, these photographs have a simple and direct, almost "functional" effect. Whereas the descriptive, cognitive photographs are constructed mostly as visual fields in which many details intensify into a mutilayered fabric of nexuses, the "true" Newtons are not constructed as fields or surfaces, but as depths. In the familiar form of perspective viewing as potential seizure, they always have one motif in the foreground, in the centre of the picture: a woman, a model (a distinction Newton makes between woman and commodity), a couple, a breast, a shoe, etc. This motif – whether humans or accessories makes no great difference, since what is important is not the objects or the people in themselves but only the figure of seduction – are presented against a background, a wall, the interior of a usually richly furnished house, the city; and often a glooy or dark background. Against these backgrounds, a spotlight or flash illuminates the motif. A similar aesthetic was found in theatre before the minimalistic phase, in film before the neo-realistic renaissance *(The Third Man*, for example, or Erich von Stroheim's films, or Fritz Lang's *Metropolis)*, and in Weegee's police photographs. All these pictures are dominated by strong black-and-white contrasts; certain elements, traces, tracks, or the actors are glaringly illuminated, everything else vanishes hopelessly into the darkness of time. The principle of voyeurism needs this alteration between light and darkness. When everything is bright and visible, the engine of fantasy, of desire, grinds to a halt. The classical voyeur prefers to sit in the shadows, in a darkened auditorium, and behind the illuminated setting and between the props it is also dark. Here the voyeur's fantasy unfolds, oscillating between seeing and imagining. Newton does his staging on location almost exclusively with lighting effects (and from the viewpoint of the "eyes"), adjusting the lighting to the extent to which the

model is undressed. *He stages realism.* In one of his black-and-white photographs, mounted policemen are tracking down two women in the undergrowth in broad daylight, and similarly his photography acts as if it has just discovered a motif, as if it had taken someone by surprise in a secret, private activity (but with a slight delay, which is why the women are hardly surprised). And this tracking down always seems somewhat strained, just as the eyes smart when they are suddenly blinded by light.

Thus far his choreography is simple. Yet here already the fissures emerge, since the illuminated scenery does not always appear quite so realistic, it allows the artificiality of the staging to shine through – for example the two women, one whipping the other.[8] Before we look at these breaks, however, we must first examine how Newton tracks down his motifs: in the brightness of daylight streaming into the room, in the glitter of large chandeliers, in the sparse light from a street lamp, or in the photographer's flash-gun, we perceive a naked woman in high heels, a woman and her mirrored reflection, a woman with another woman, a woman and another woman impersonating a man, a woman and a dog, a woman and a mannequin, a woman and an automobile part, a woman and banknotes, a naked woman in a dark street, a woman with stockings, with prosthesis, with chains, with a pistol, with a plaster cast, in fetters – women in every imaginable state, only not in working situations; women in all possible functions of male fantasies, always women, only rarely does a man play a part, since he could block the projections, and we also seldom see groups or group photos, as in the belatedly published *Saturday Night, Orange County, California 1983*,[9] and with only few exceptions the women always appear strong, self-conscious, "maters of the situation", play the stronger sex, are prepared for sexuality, already entangled in their own dream, their own fantasies. It is a lascivious, cool, disreputable and elegant lady who leads us through the world of Newton's imagination.

Walter Seitter has drawn attention to the prominence and "metonymies" of this juxtaposition of the "associated", which needs another person or the opposite sex, but where an animal or a statue can also suffice.[10] This doubling of often antithetical pictorial elements does not serve to alienate sexuality, to reify it, or even to transform or re-

voke it. These combining or contesting couples arouse curiosity and awaken latent images in the beholder. They function as stimulants in the staging, they prevent the woman portrayed from ever being a nude in the classical sense of figure studies or as naked in the biological sense. A fur emphasizes the nakedness of the woman it clothes, dark streets make a woman's nudity appear as an urge to expose herself, a woman with open legs and an attacking Alsatian dog emphasizes the animal side of sexual passion (beyond what society tolerates), discarded clothing or even a whip augment the concept of sexuality with the important aspects of violence and passion. Stockings and straps are the aesthetic guardians of the secret centre of the earth. The women are not dressed in an everyday manner but are outfitted for a profane sacrament or for battle.[11]

One of these objects, instruments or, to be more modern, machines deserves a closer look, although it is part of the classical inventory of erotic photography: the shoes or stilettos that represent something like the elixir of life in Newton's photography. It is difficult to find a woman in Newton's pictures who is not wearing high heels. This subject has been treated in great detail, from the lashed feet of the Chinese to the helplessness of women in stiletto shoes. It is to Newton's credit that he has introduced new semantic aspects to the wearing of shoes: the women seem to be wired, like a plug in a socket, the current and energy flowing freely. It is obvious that the shoes in many cases are not meant as devices for walking but instruments to stir up the imagination, as weapons in the daily effort of self-assertion, not to be compared with protheses for supporting the weak but as swords which men once wore, or as thorns in one's own flesh. The women wearing them never appear helpless; instead, the pictures suggest that the shoes magnify the strength already present. On the other hand, however – these shoes have several reciprocal interpretations – they cause the women to solidify, transforming the liveliest action into staging, to poses, and the women wearing them into statues, as if they had been cast into these forms.[12] Walter Seitter and Dominique Baqué correctly emphasize this solidification in their essays.[13] Seitter points out the affinities with neo-Classicism, to sculpture-creating cultures – Newton's women are indeed never romantic, never Biedermeier-like, never Sarah Moon-like, and there is

always a waft of violence and latent aggression in the air.[14] Baqué uses Nietzsche's well-known distinction to show that Newton's women and settings are always Apollonian and never Dionysian, that his women never lose themselves in excitement, are never consumed by their passion (never become *informe*, as Bataille has put it), but that they always maintain their form, beauty and composure, that they are therefore not erotic in themselves but only exhibit the signs of eroticism.[15] Newton's women all have one or more accessories of male fantasies, but as a rule they do indeed appear self-contained, maintaining the integrity of their own form, and are never directly confrontational, not even toward the viewer: "They look at no one directly."[16] This lends distance to the settings, it solidifies them.

To recapitulate and expand, Newton uses the aesthetics of flashes of light (even without his flash-gun) as if he were a society photographer, a Weegee of eroticism, a paparazzo and detective in one person. For this instant aesthetic, it is quite fitting that the flash illuminates the forbidden, mysterious domain of the rich and beautiful, that we can experience a small portion of their environment and amusements: in 1/250th of a second, the object of voyeuristic lust and the subject of our own desire appears, with a bit of atmosphere added. Newton is a new type of court photographer for our present-day courts. The dark expanses into which light shines underscore the prohibited, the crime which the photographer or his subjects are engaged in – even if it is only the "crime", the luxury, of truly having time for the sexual – the expanses leave room for projected digressions. In contrast, the illuminated figures appear unsurprised, do not react at all, but continue doing what they want to do, continue to pursue their own thoughts and fantasies as if there was no disturbance; often the captured moment is so strong that the diverse quality of the photographic technique, the choreography of the portrayal, the model and the background create a complex, often paradoxical, ambience. In doing so, Newton largely avoids the trap of the "imaginary realistic" and achieves the "symbolic".[17] Newton thus shatters his own illusion of reality, creating in its place an ambivalent and fascinating world of images. He shows not only "woman and" but also "woman as": woman as a sexually aware being, woman as the stronger sex no longer in need of a man, as a person combining strength and sexuali-

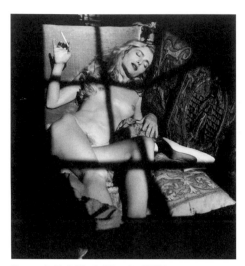

3 p.m. in Bel Air, **California 1987**

ty (*Big Nudes* and *World without Men*), sexuality as a power play; he thus creates visual metaphors which transcend a merely voyeuristic and pornographic approach, which allow us to look at the photographs many times, even to examine them for longer periods. It is also this disjunction that allows a comparison with the suspense of Hitchcock. A setting full of tension. A stylized theatre with the realism of an actual setting, which despite the touch of violence leaves the observers unthreatened, confronting them merely with their own moral concepts.

This was true in the mid-eighties in any case; since then, the Newton canon seems to have shifted once again. In his magazines and in the publication *Archives de nuit* a stronger realism is evident, an intensification in his approach to the world, to the situation, to sex. Several explanations are possible: this is the way he is now taking photographs; or he has drawn on other, previously unpublished photographs from his archives; or he is trying to create connections between sex and power, between sex and money, sex and religion, between the private and public, in a number of pictures (in "Pictures from an Exhibition", for example) that suggest a macabre, perverse, cruel but also more passionate world. The photograph *Siegfried* becomes an image of animal obsession, power struggles; fellatio in the picture *In a Penthouse* narrows the optical effect from erotic fantasy to the pornographic gaze. But what is also visualized is an unaffected, relaxed, unbiased sexuality, which was not yet admitted in the subdued eroticism of the late seventies. The series with Fräulein Petra, who appears dissolved, *informe*, despite the "Fräulein" and changes of shoes from scene to scene, the picture *Smoking Nude*, and especially the reposed and shoe-less model in *3 p.m. in Bel Air* all suggest a free expression of sensualness and sexuality that Helmut Newton and his form of public expression did not previously permit; they finally also suggest a self liberated from staging and liturgies.

The voyeur in the true sense is a participant without direct consequences. Voyeurism as a mixture of dream and reality is the visual realization of dreams, fantasies, desires – which are more realistic than dreams and less painful, less problematic and injurious than reality – and a visual realization of the fundamental principle of a

society in which the dominance of the visual, the visible (the photo-graphic!) super-sedes all other senses and their objects, e.g. tangible material, and makes of all of us observers in the darkness. Since, however, the visible, the action illuminated by blinding lights, must supplant all other impressions, including that which in reality smells, reeks, or can be tangibly explored, it is forced again and again to escalate up to the pain threshold of the eye and the spirit. What type of voyeurism will Newton – who has always had the energy and imagi-nation to keep pace, always near the borderline of what is publicly acceptable, who has strongly influenced the artistic climate for two decades – offer to the more painful nineties?

1 Helmut Newton, *Nuevas Imagenes*, p. 82, exhibition catalogue for the exhibition of the same name in the Sala de Exposiciones de la Fundación Caja de Pensiones, Madrid 1989.
2 Victor Burgin, "Espace pervers", in *Art Press, Spécial, La Photographie – L'intime et le public*, no date (1990), p. 64.
3 Ibid., pp. 62ff.
4 Ibid., p. 64.
5 Jean Baudrillard, *Cool Memories,* 1980–1985, Munich 1989, p. 9: "It is not the figure of seduction that is mysterious, but the subject caught up in his own wishes or image."
6 Laura Mulvay: "Cette seconde possibilité, la scopophile fétichiste, construit la beauté physique de l'objet transformant celui-ci en quelque chose de satisfaisant en soi." Quoted from Burgin, op. cit., p. 66.
7 Serge Tisseron, "Le mystère de la chambre invisible – A propos d'Helmut Newton", in *La Recherche Photographique. L'Erotisme,* No. 5, 1989, pp. 83ff.
8 Interior, in Helmut Newton, *Sleepless Nights*, p. 69.
9 See *Helmut Newton's Illustrated*, No. 2, 1987
10 Walter Seitter, "Helmut Newton lesen", in: S. Gohr and J. Gachnang, *Bilderstreit*, exhibition catalogue, Museum Ludwig, 1989, pp. 185ff.
11 Ibid., p. 127.
12 Ibid., p. 126.
13 Dominique Baqué, "A corps pordu", in *La Recherche Photographique*, No. 5, 1989, pp. 73ff.
14 Klaus Honnef, "'Ich bin ein guter Beobachter von Leuten', Helmut Newton und seine Welt", in Helmut Newton, *Portraits*, Munich 1987, p. 8.
15 Baqué, op. cit., p. 75.
16 Tisseron, op. cit., p. 88.
17 Seitter, op. cit., p. 126. Seitter sees, for example, a number of references and motifs from the Song of the Nibelungen in Newton's photographs.

Plates

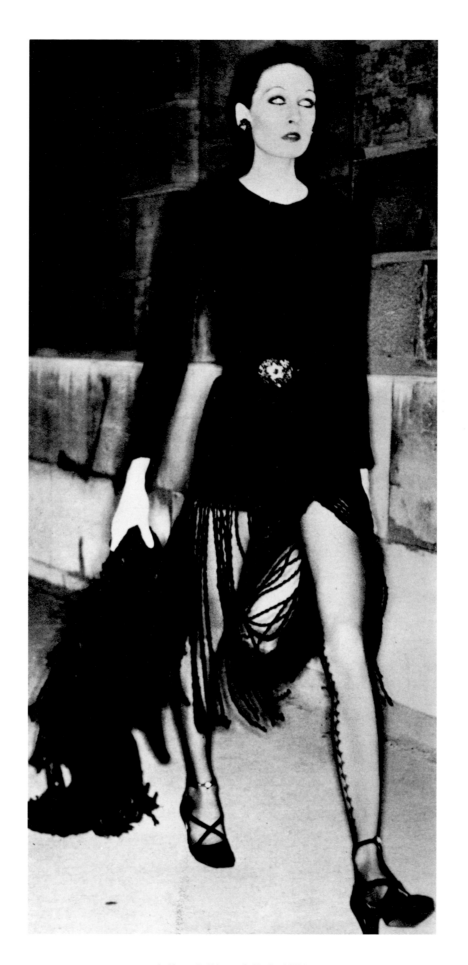

1 French "Vogue", Paris 1971

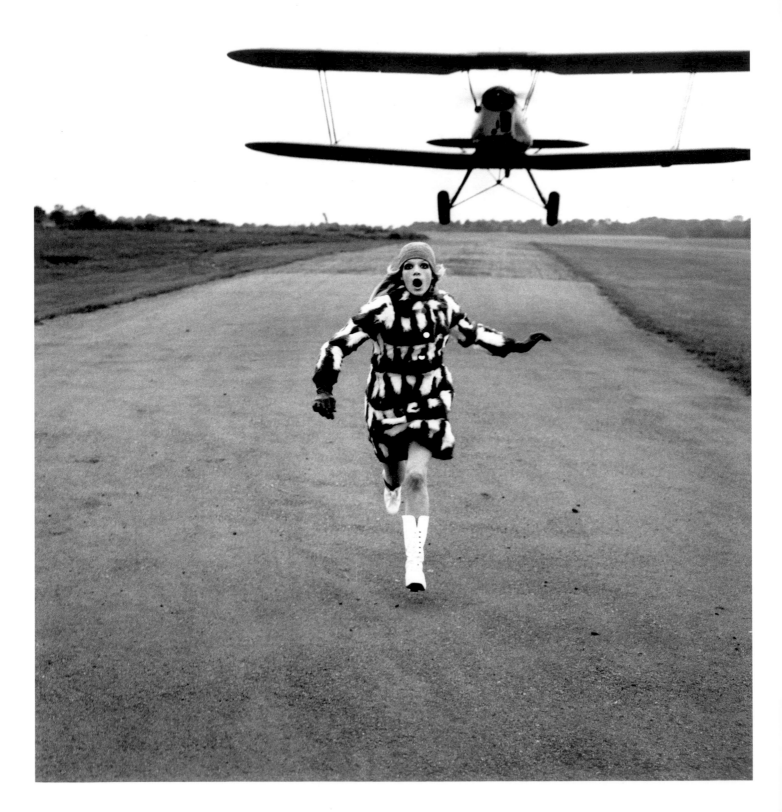

2 British "Vogue", London 1967

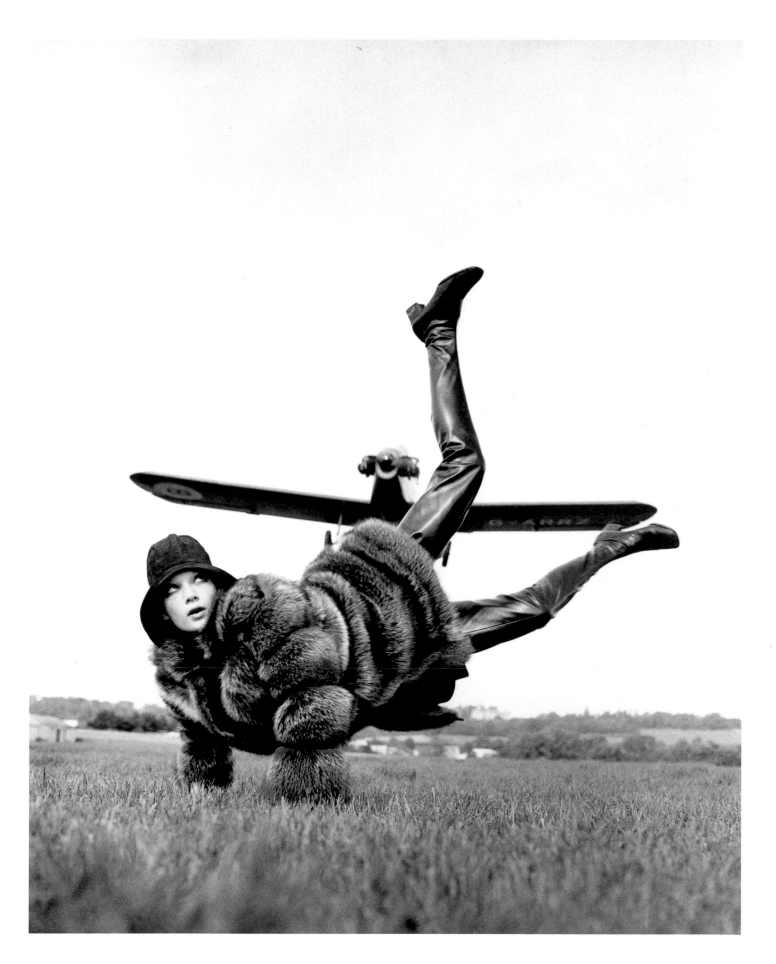

3 British "Vogue", London 1967

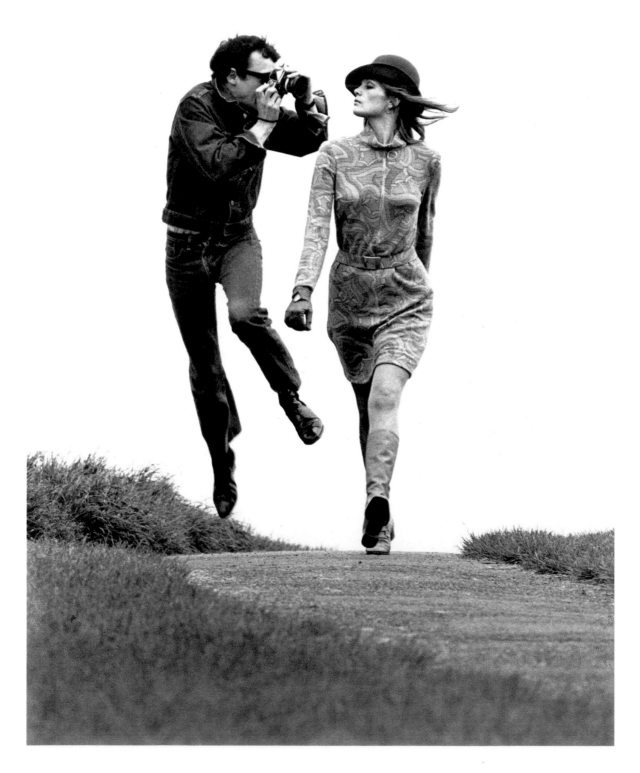

4 British "Vogue", 1967

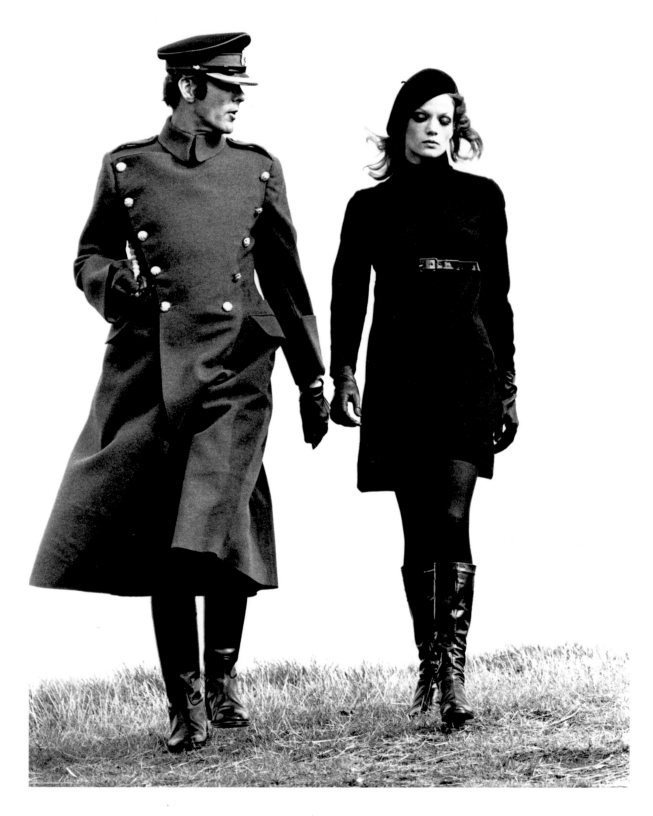

5 British "Vogue", 1967

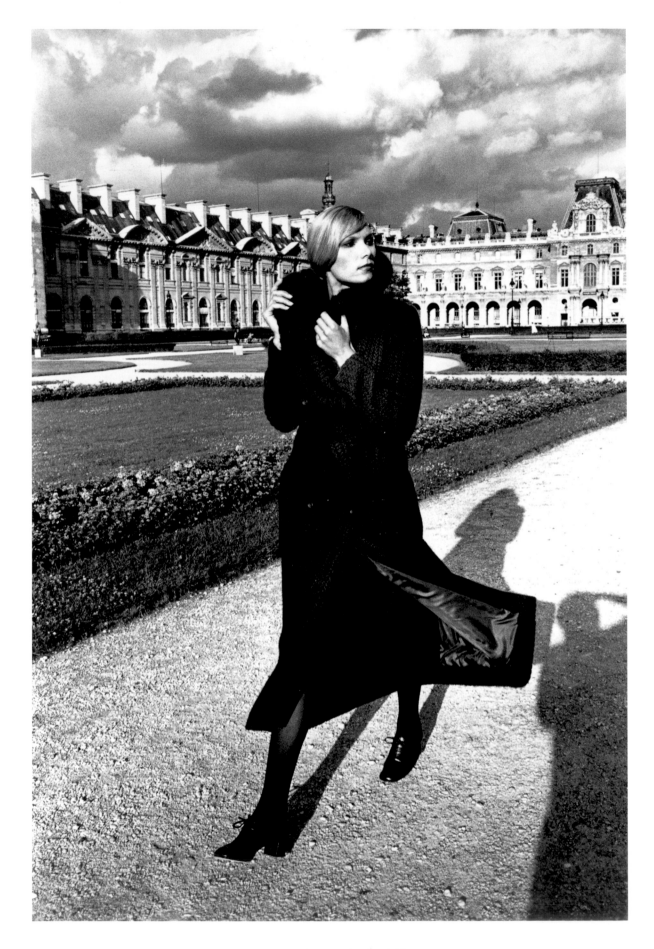

6 French "Vogue", Paris 1970

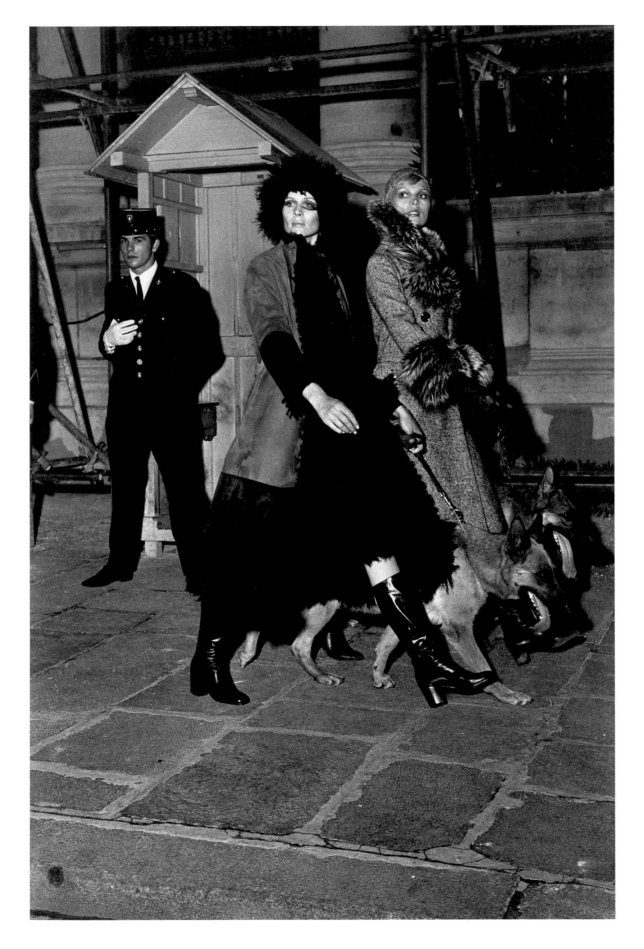

7 French "Vogue", 1970

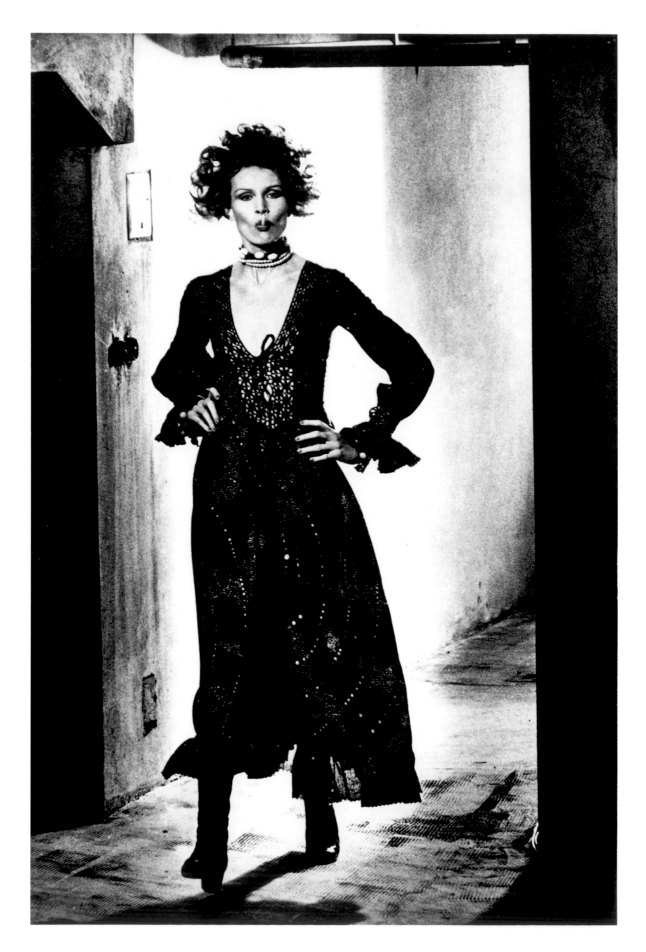

8 For "Linea Italiana", Milan 1970

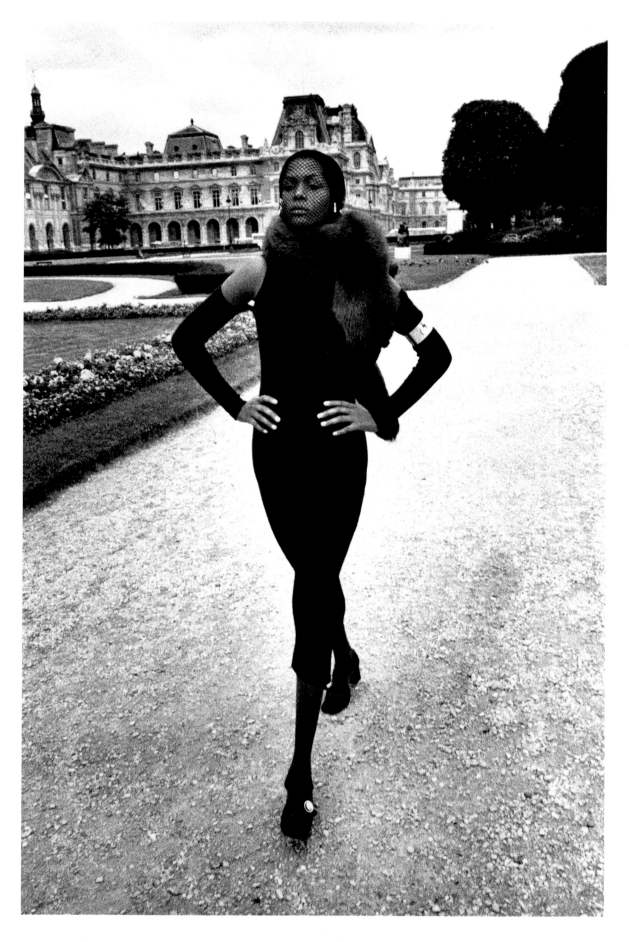

9 Tan Giudicelli for Mic-Mac, Paris 1970

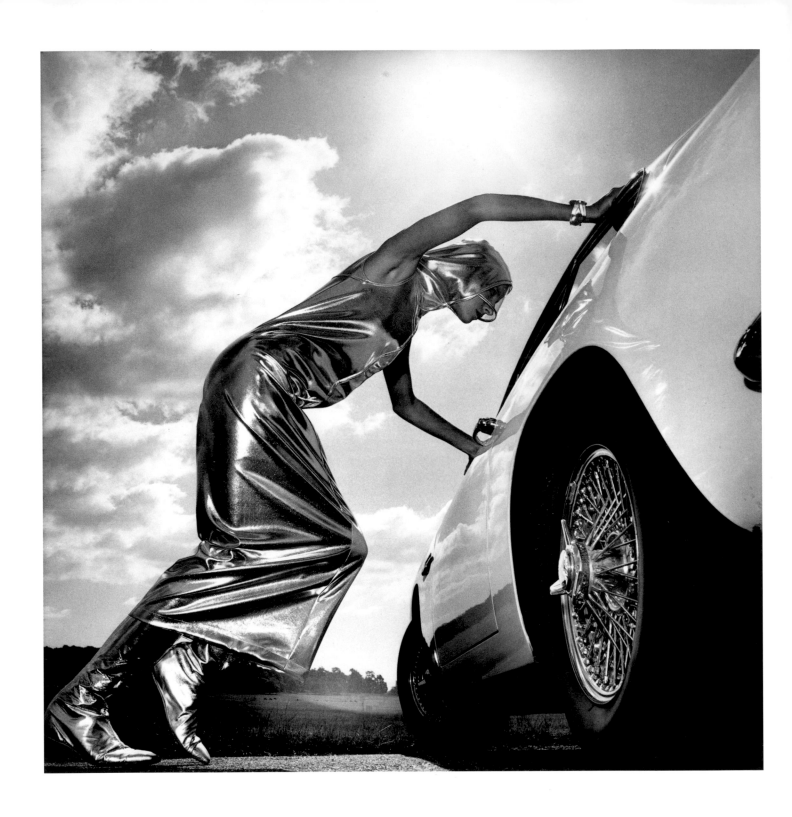

10 British "Vogue", London 1966

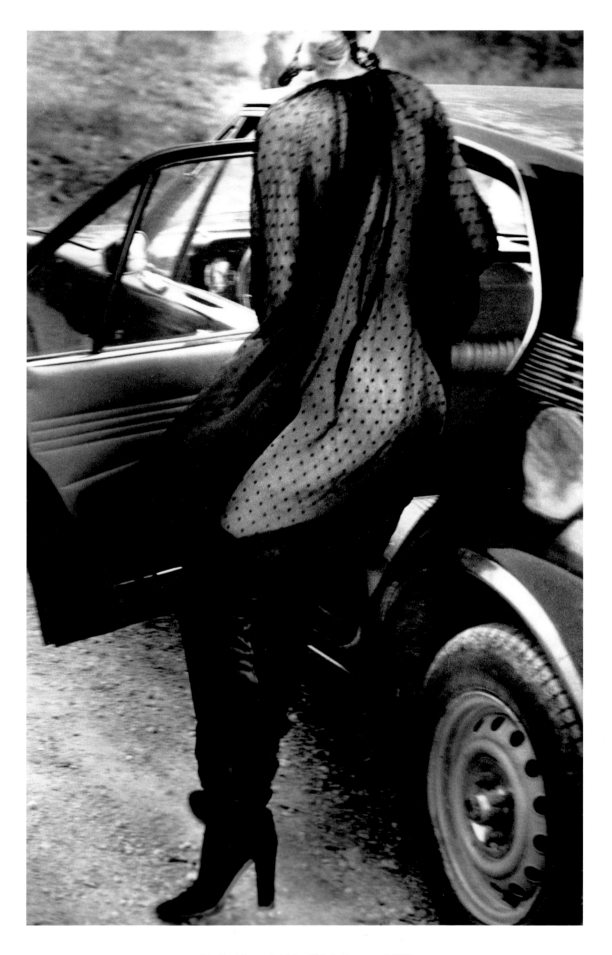

11 Karl Lagerfeld for Chloé, Tuscany 1977

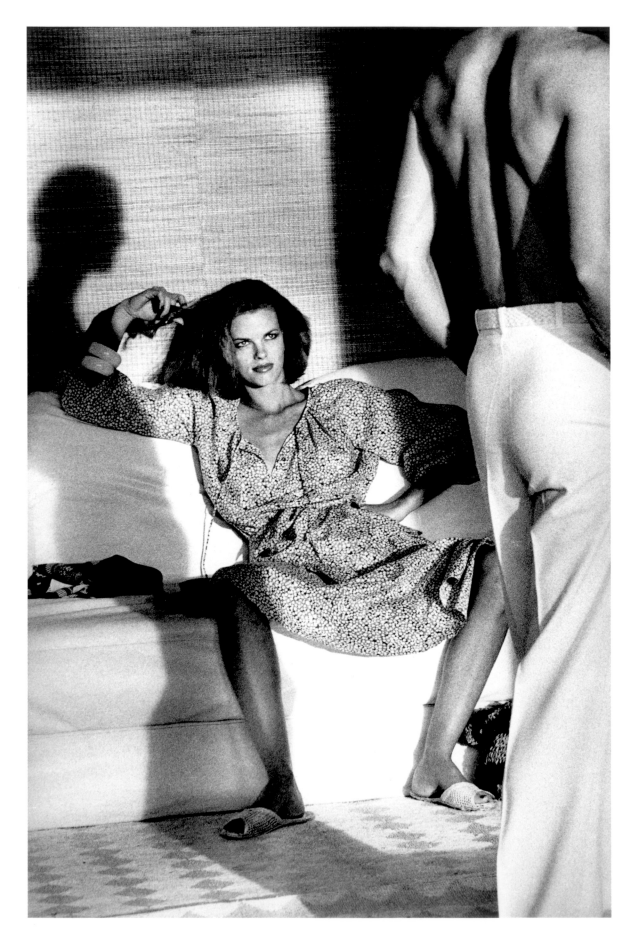

12 Woman examining man, Saint-Tropez 1975 for "American Vogue"

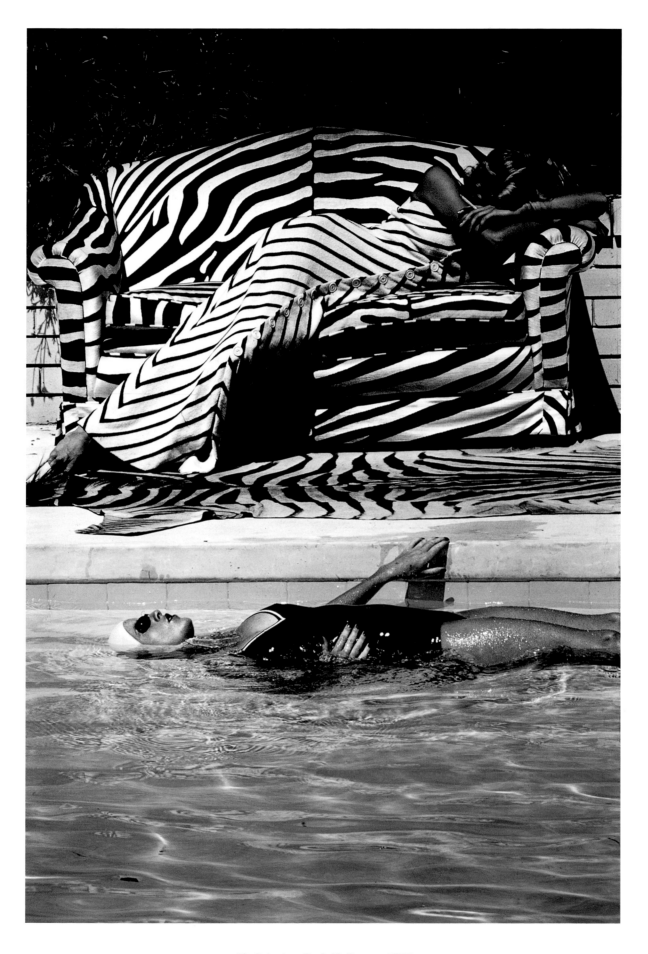

13 Suburban Pool, Melbourne 1973

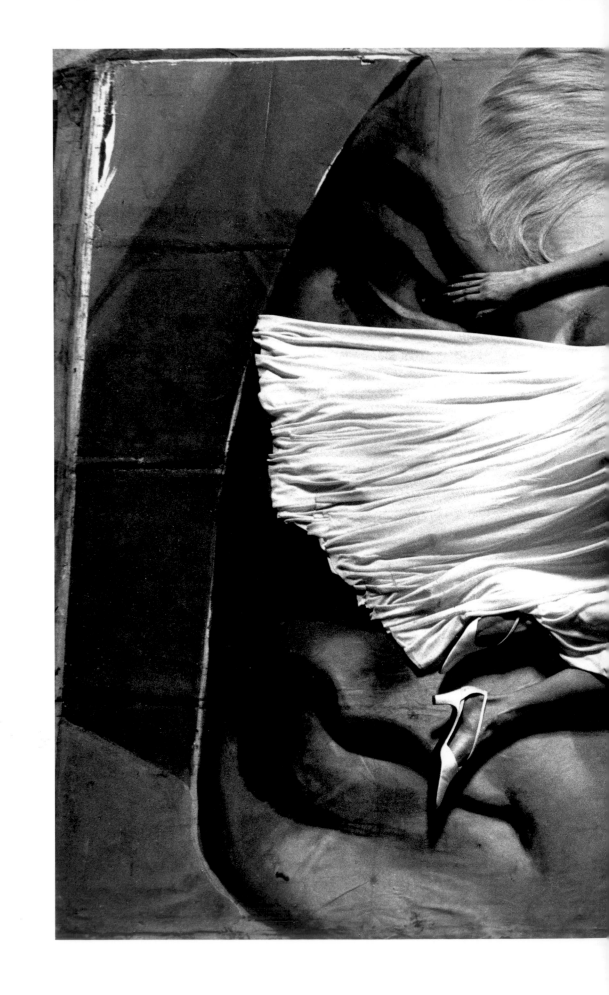

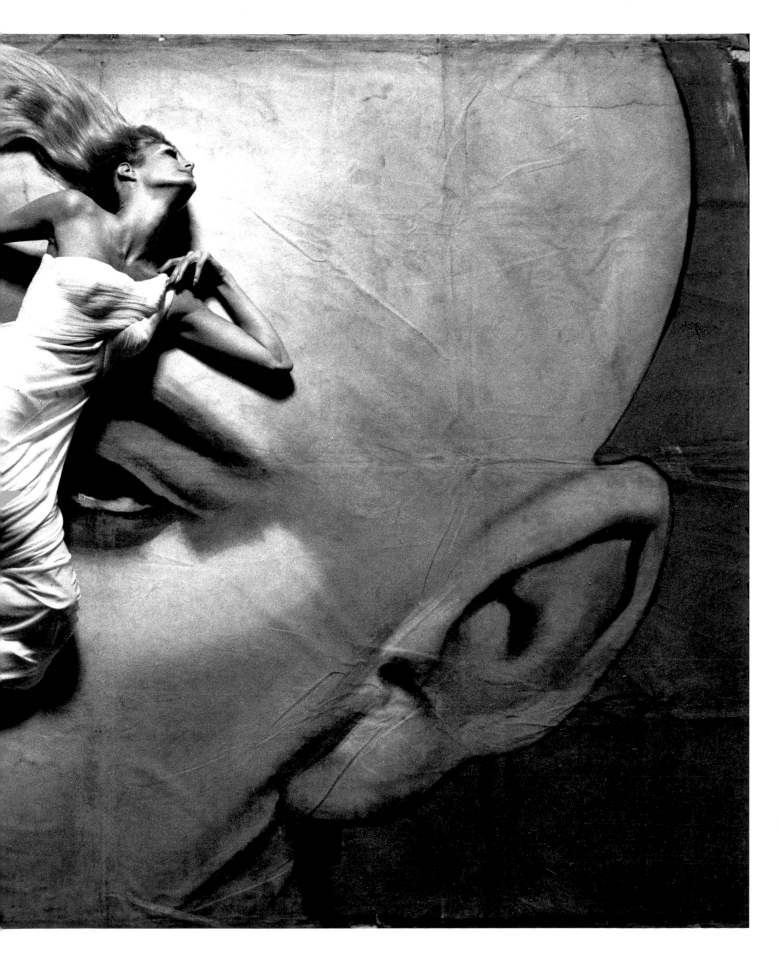

14 For "Queen", Paris 1966

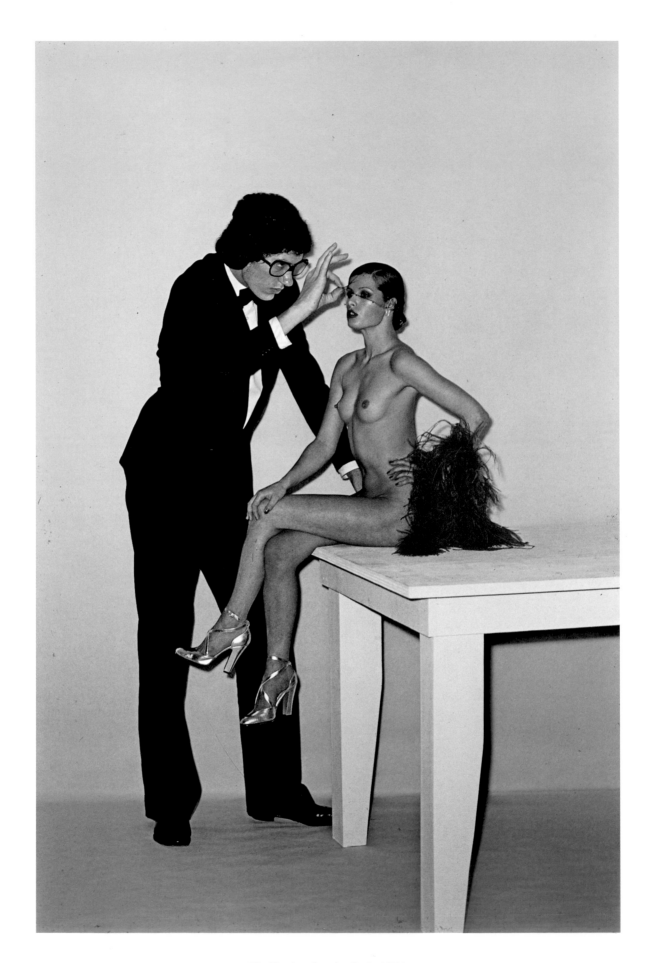

15　Giant and nude, Paris 1974

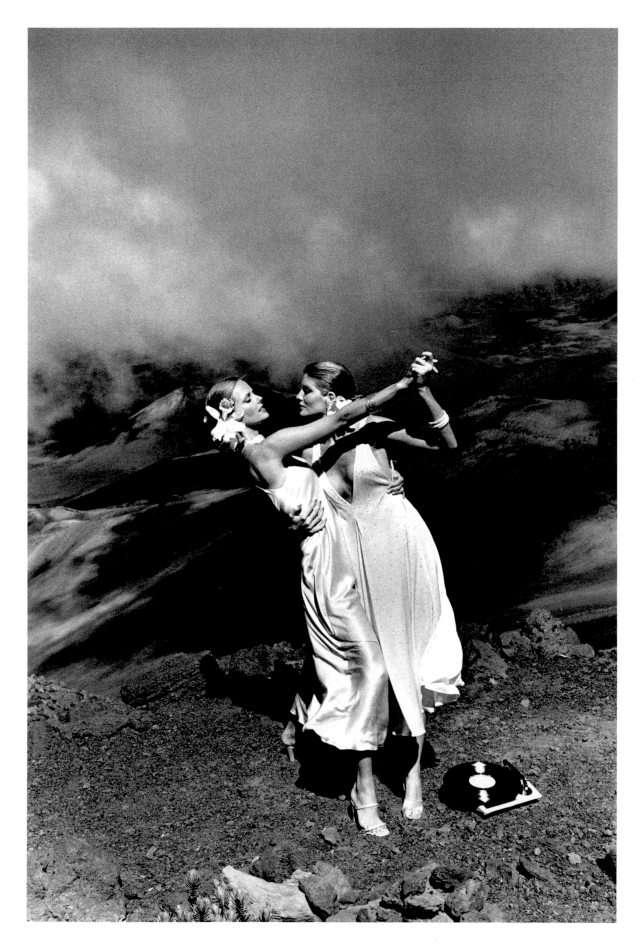

16 U.S. "Vogue", Maui, Hawaii 1974

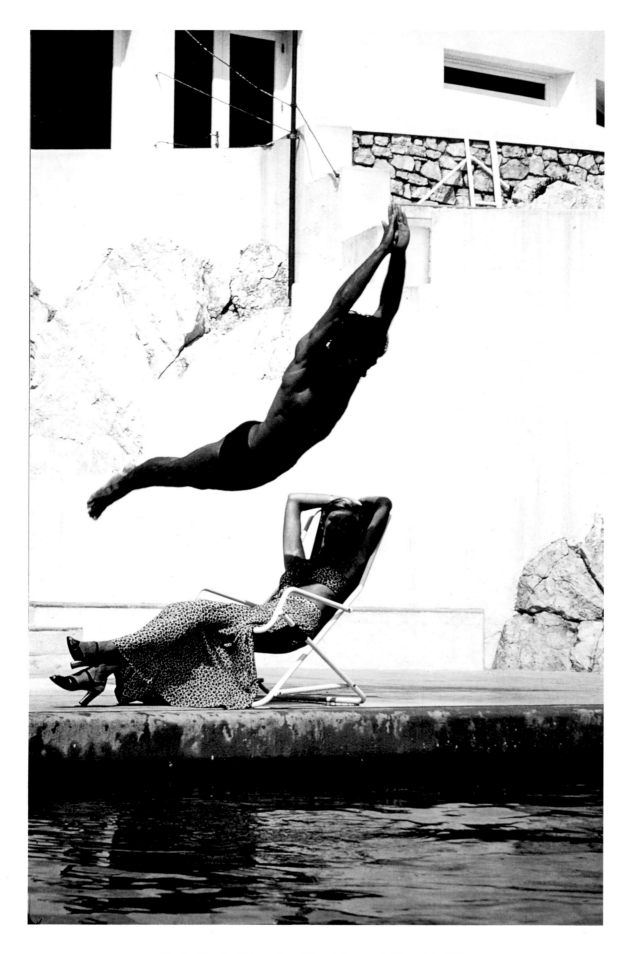

17 For "Marie Claire", Grand Hotel du Cap, Antibes, late '70's

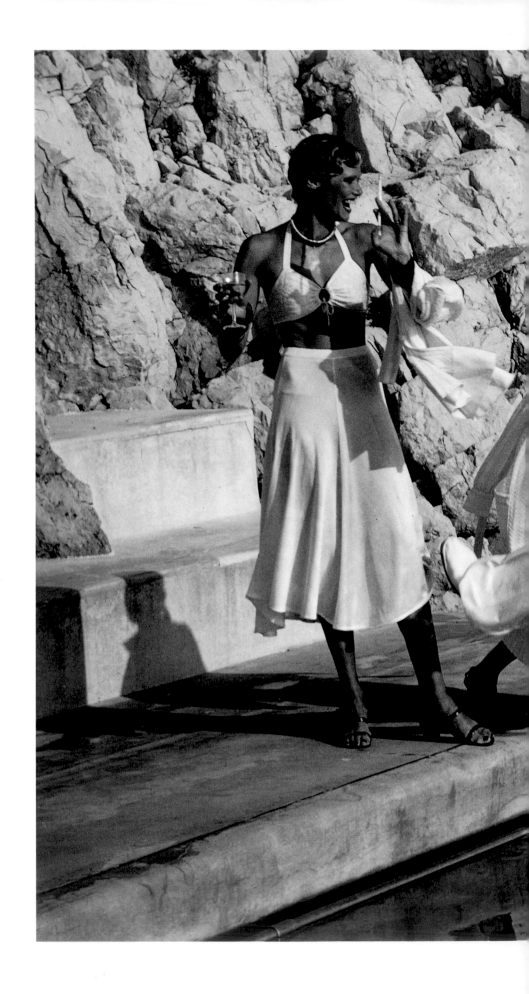

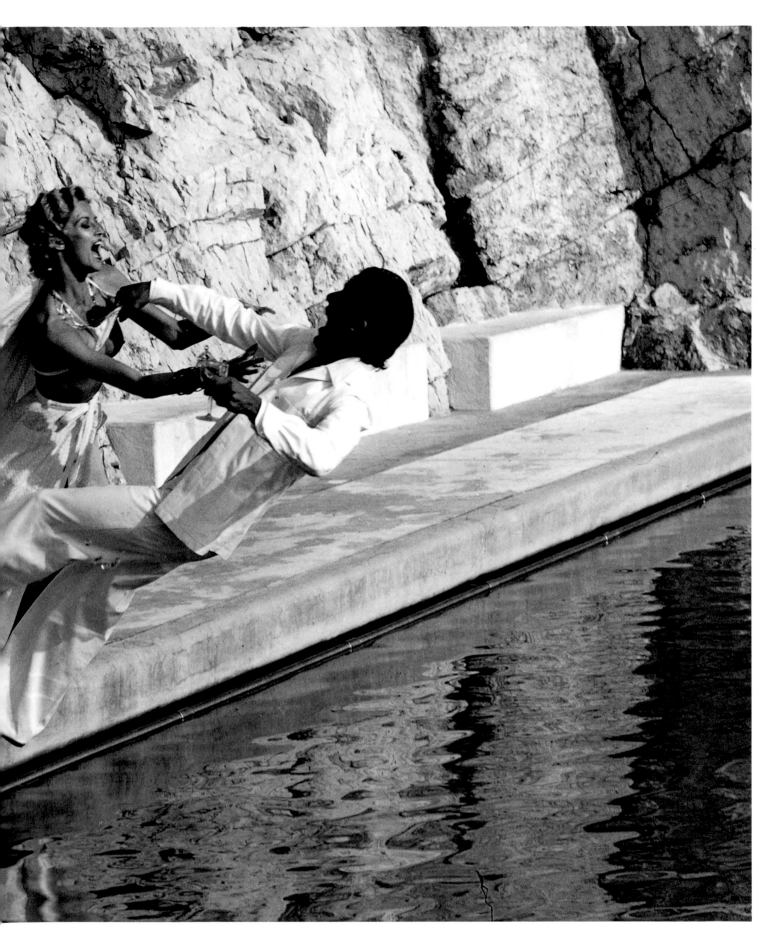

18 For "Marie Claire", Grand Hotel du Cap, Antibes, late '70's

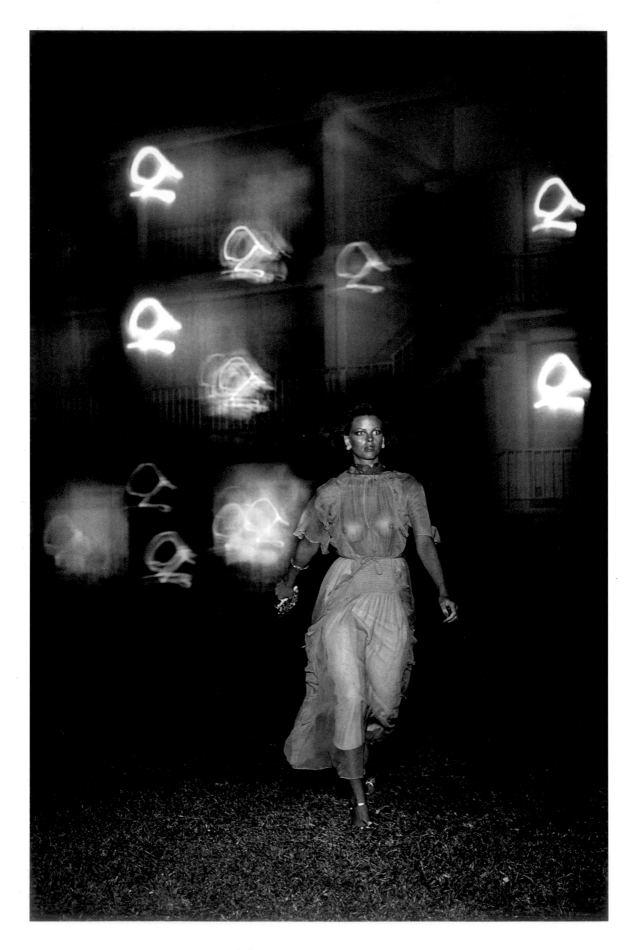

19 Lisa fleeing, Key Biscane, Florida 1974

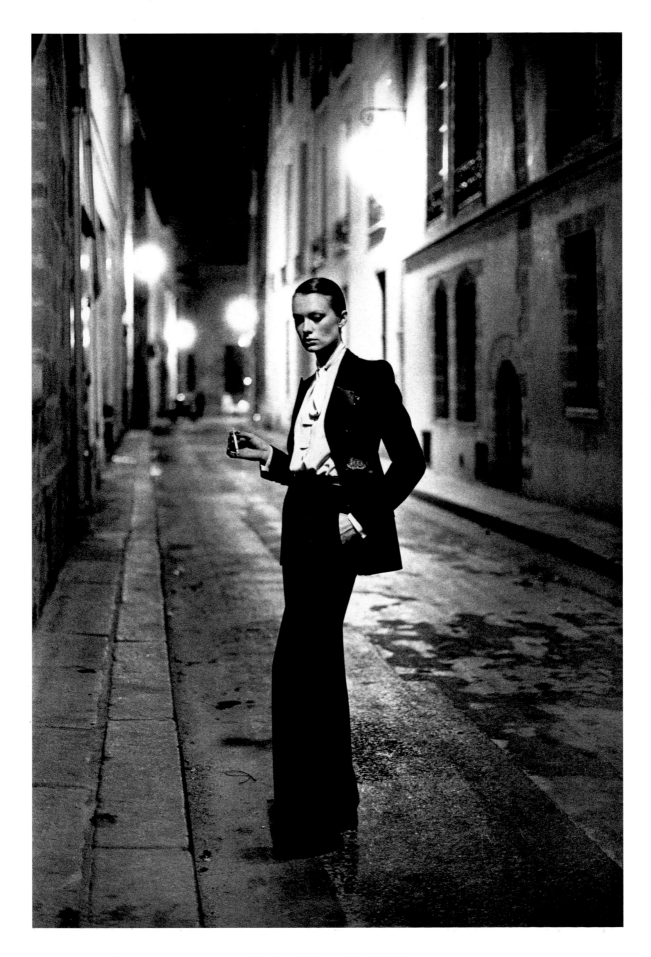

20 French "Vogue", Paris 1975

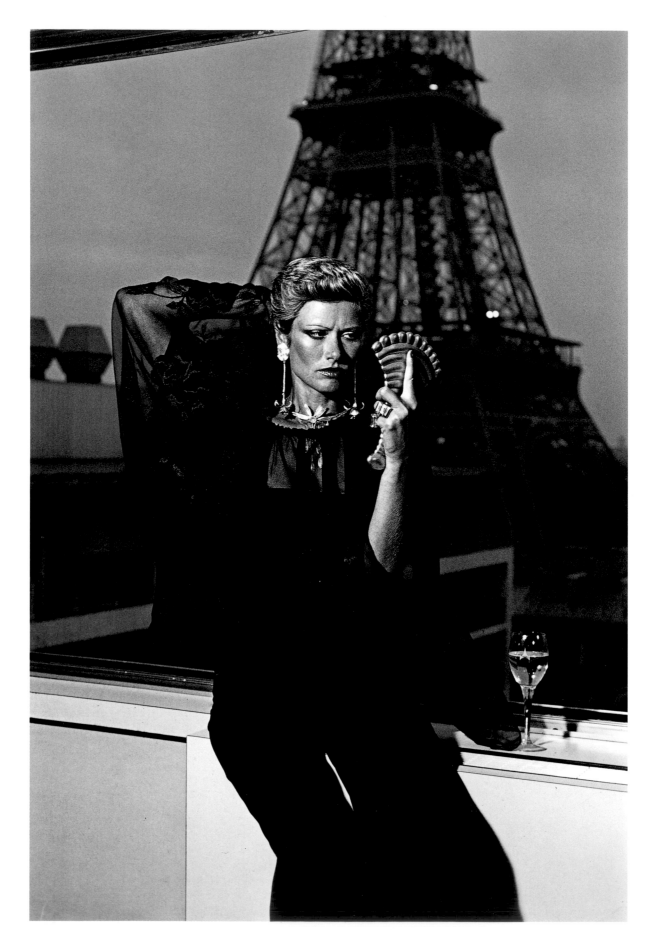

21 French "Vogue", Paris 1976

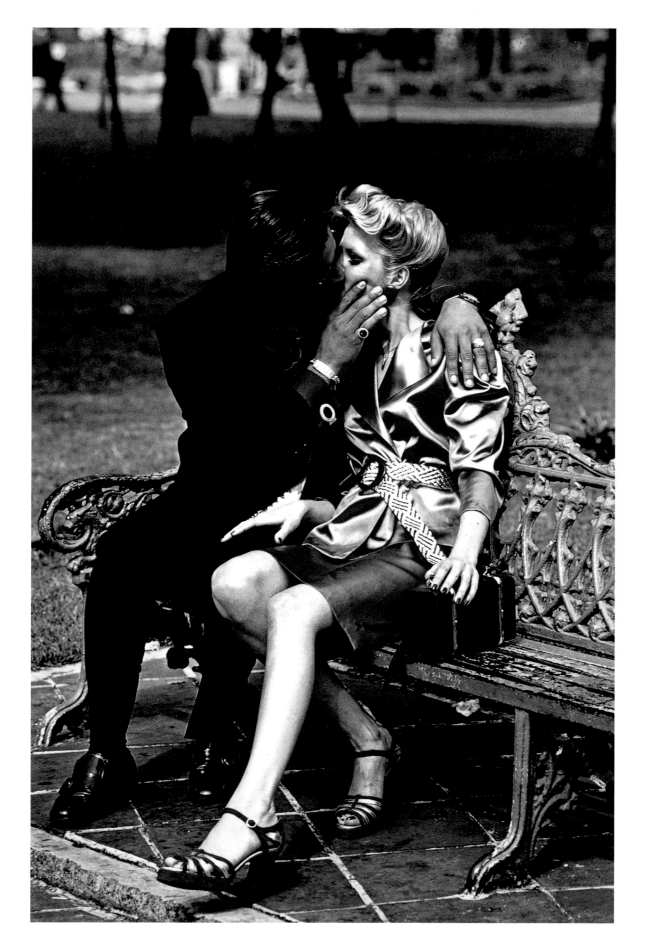

22 "Stern" magazine, 1974

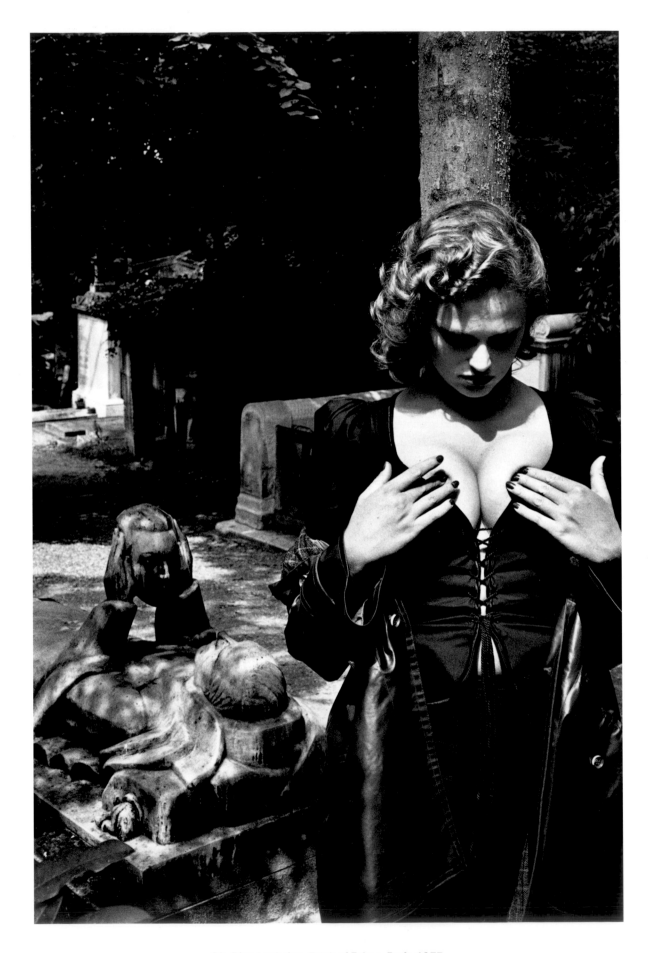

23 Père Lachaise, Tomb of Talma, Paris 1977

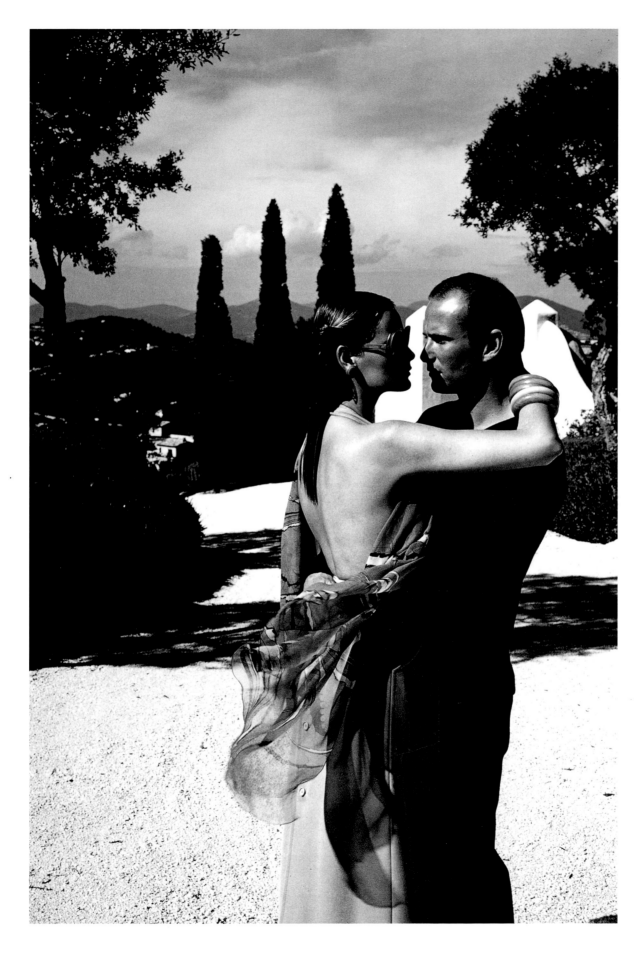

24 U.S. "Vogue", Saint-Tropez 1975

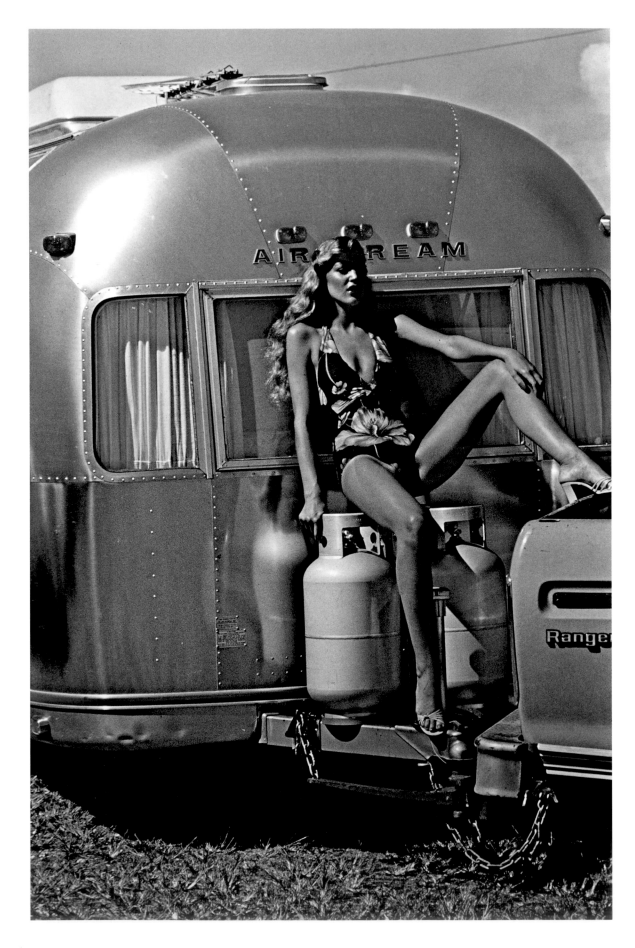

25 Miami, Florida 1974

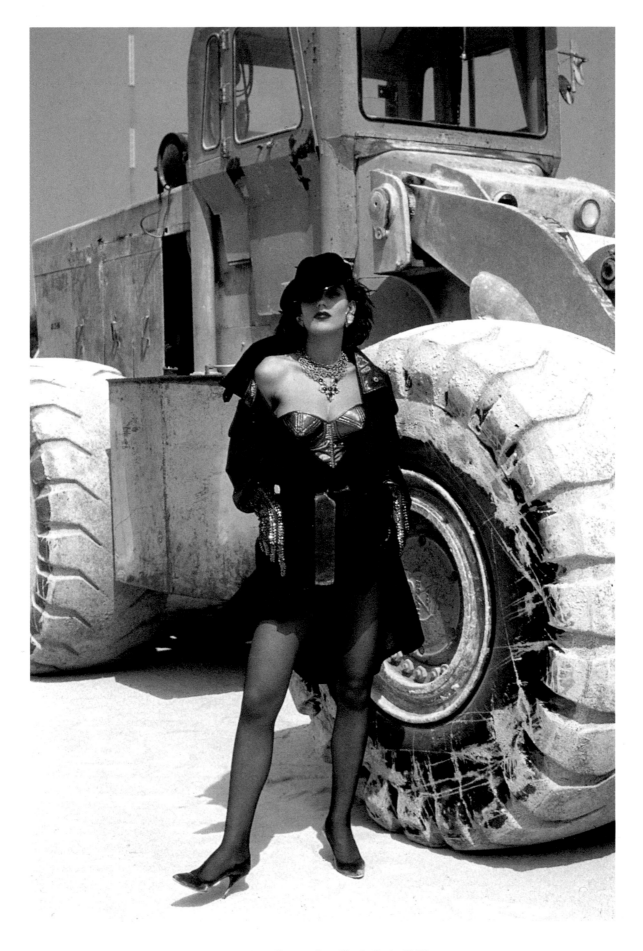

26 "Stern" magazine, Monte Carlo 1983

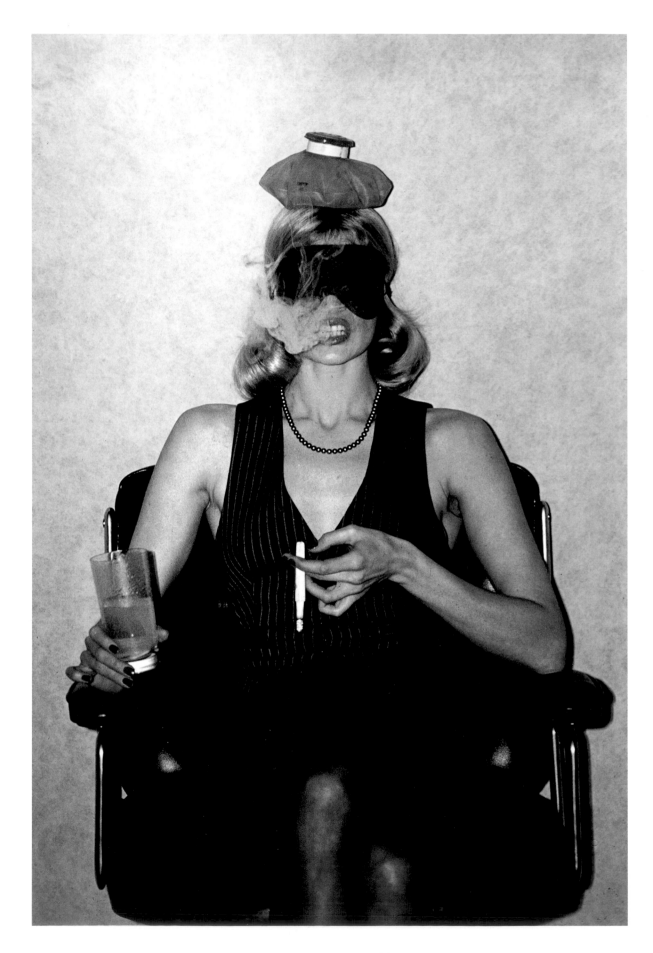

27 For "Nova", Paris 1973

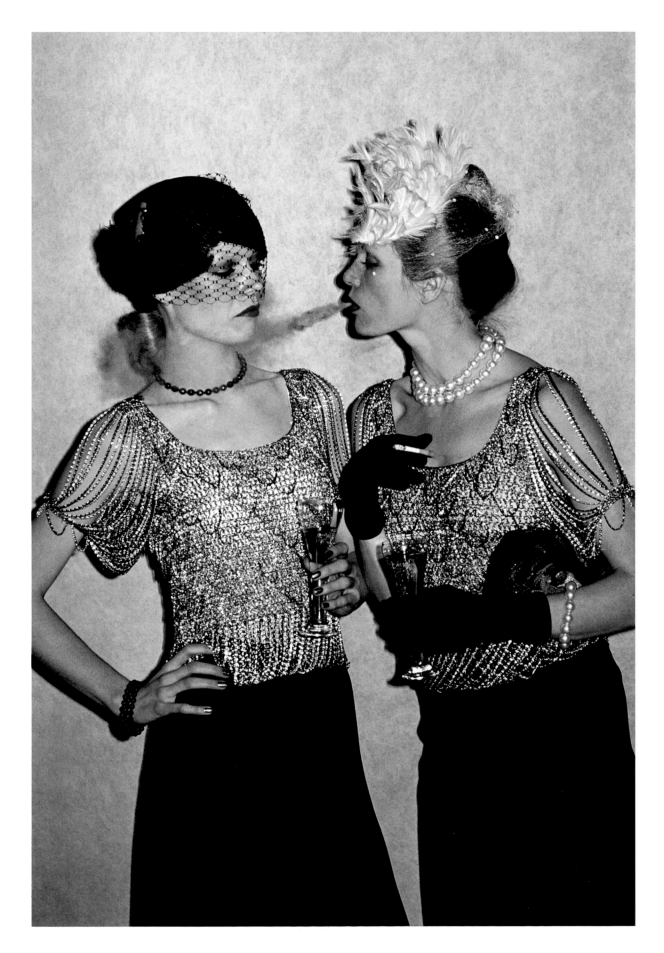

28 For "Nova", Paris 1973

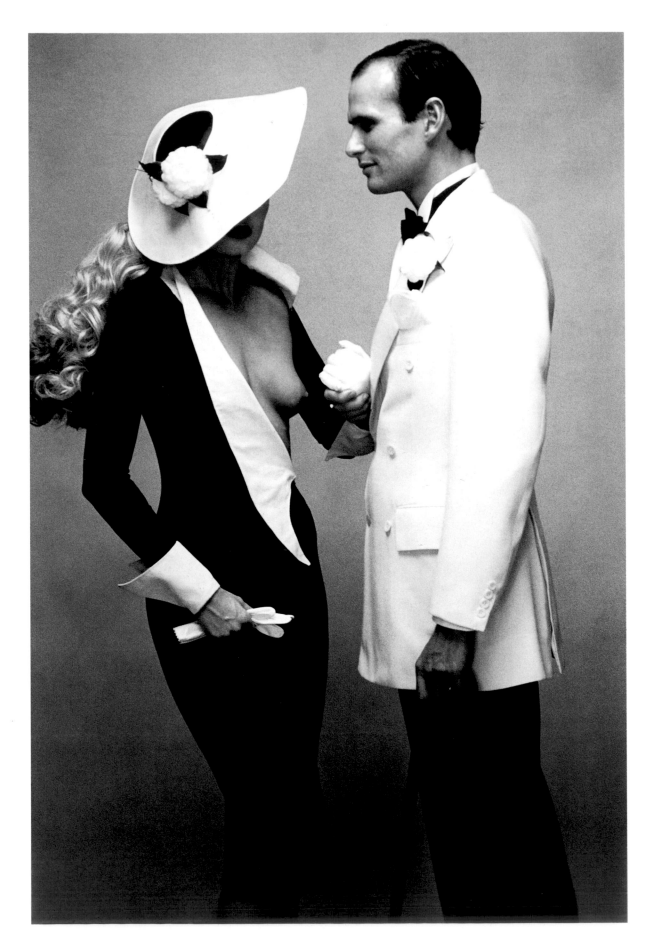

29 For "Oui" magazine, 1976

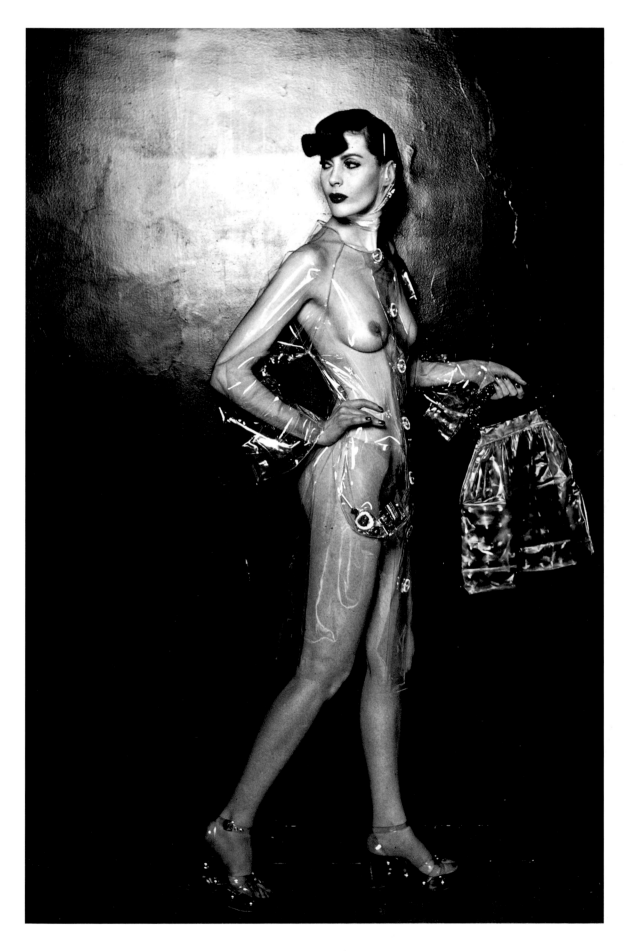

30 Fashion photo, Eija, Paris 1973 for "Nova", London

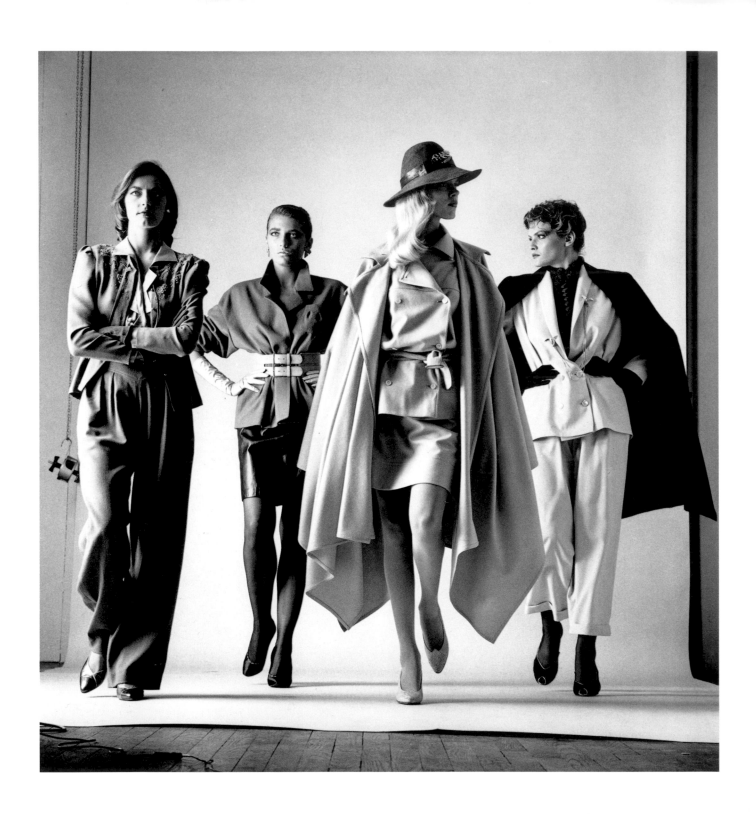

31 "Sie kommen" Dressed, 1981

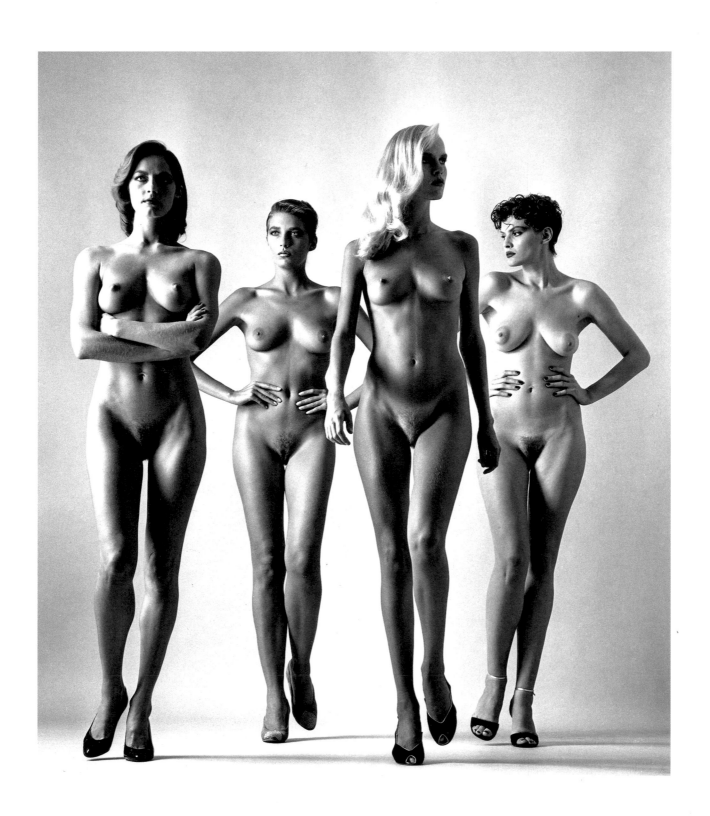

32 "Sie kommen" Naked, 1981

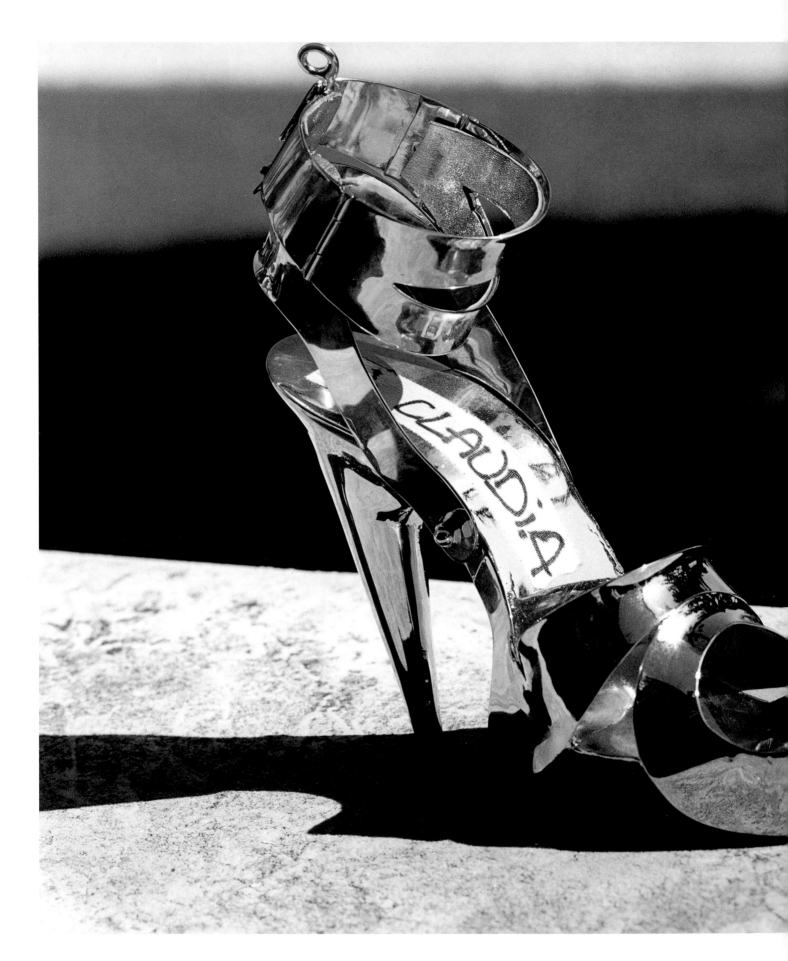

33 Claudia, Nice 1992

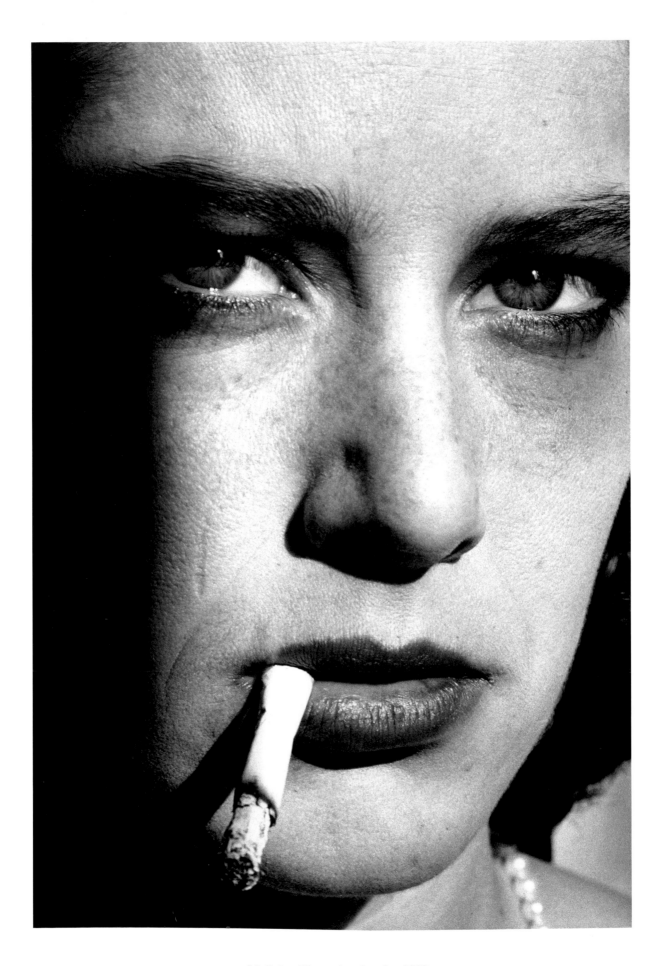

34 Debra Winger, Los Angeles 1983

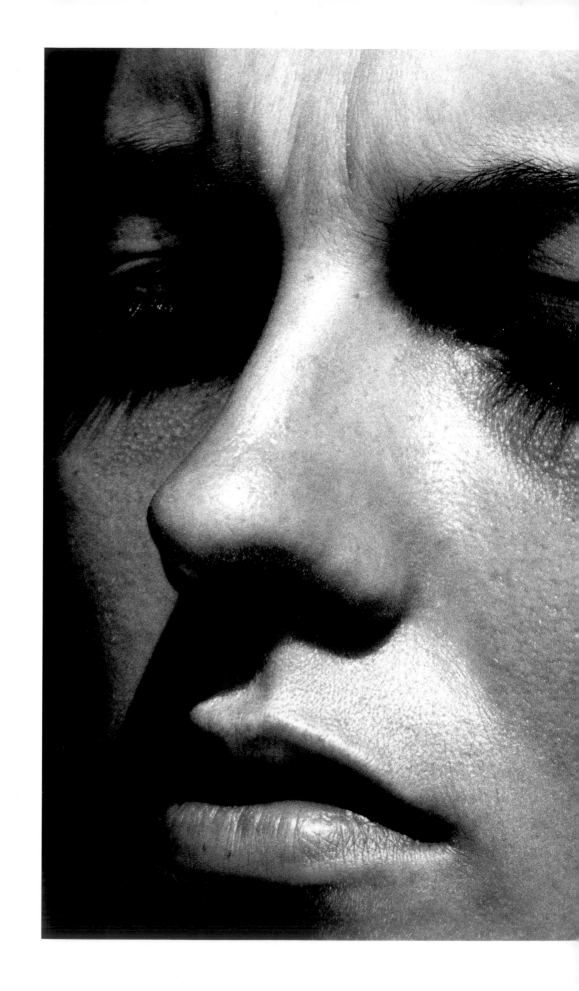

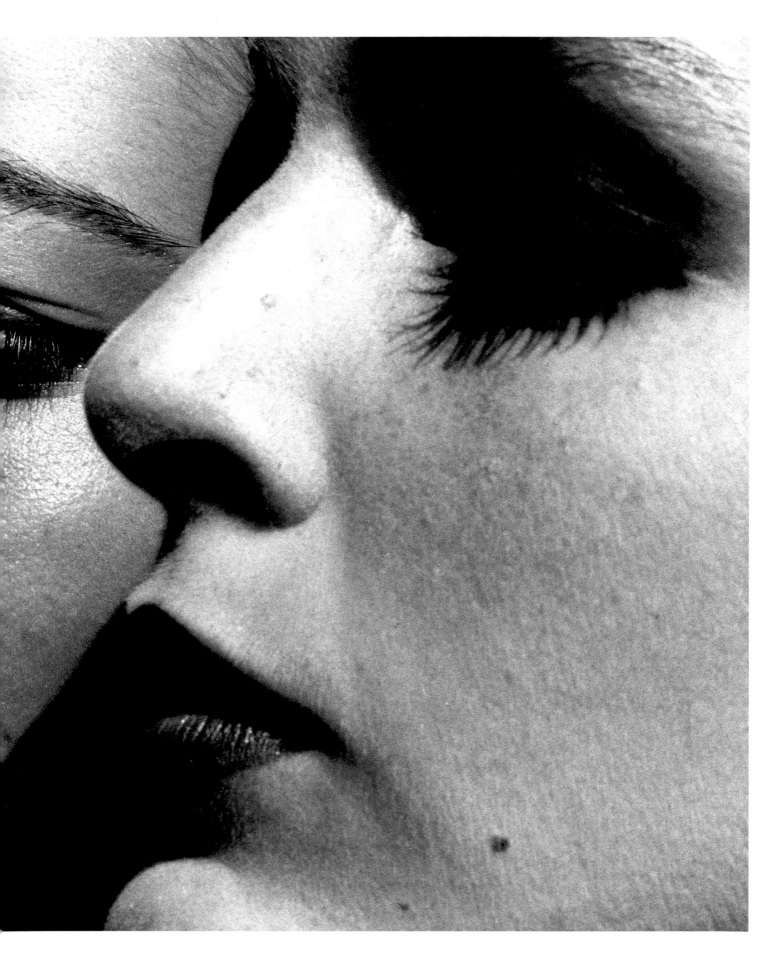

35 Two women, close up, Bordighera 1982

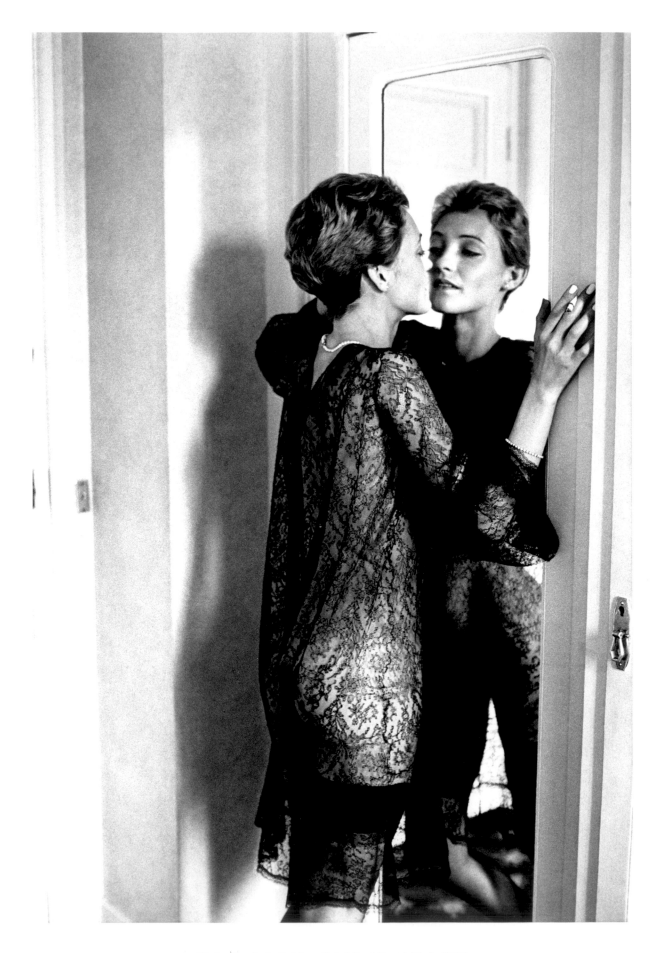

36 Loulou de la Falaise, Hotel Pont Royal, Paris 1975

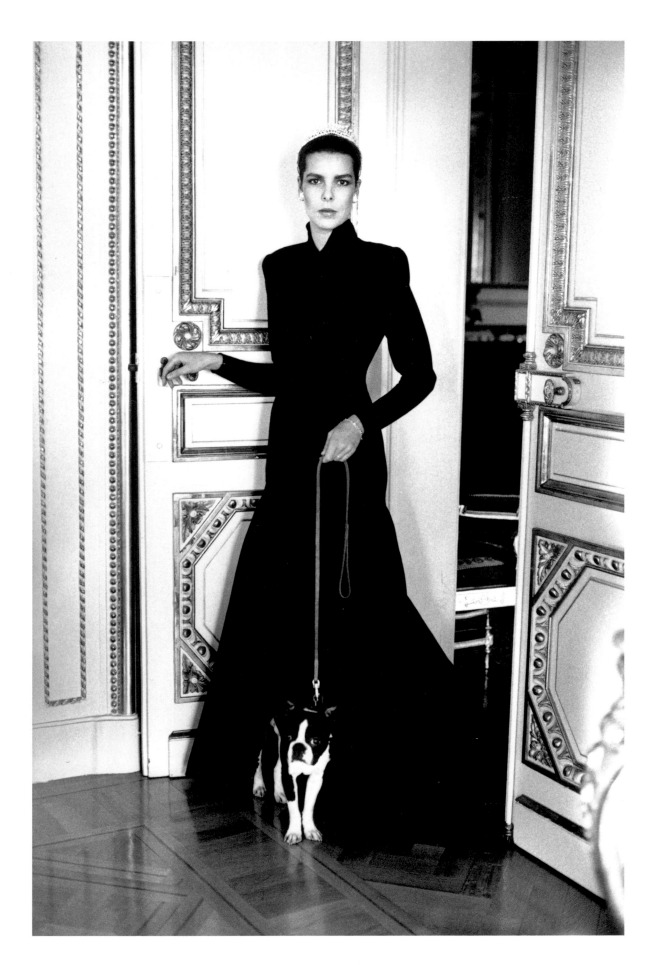

37 Princess Caroline of Monaco, Monte Carlo 1986

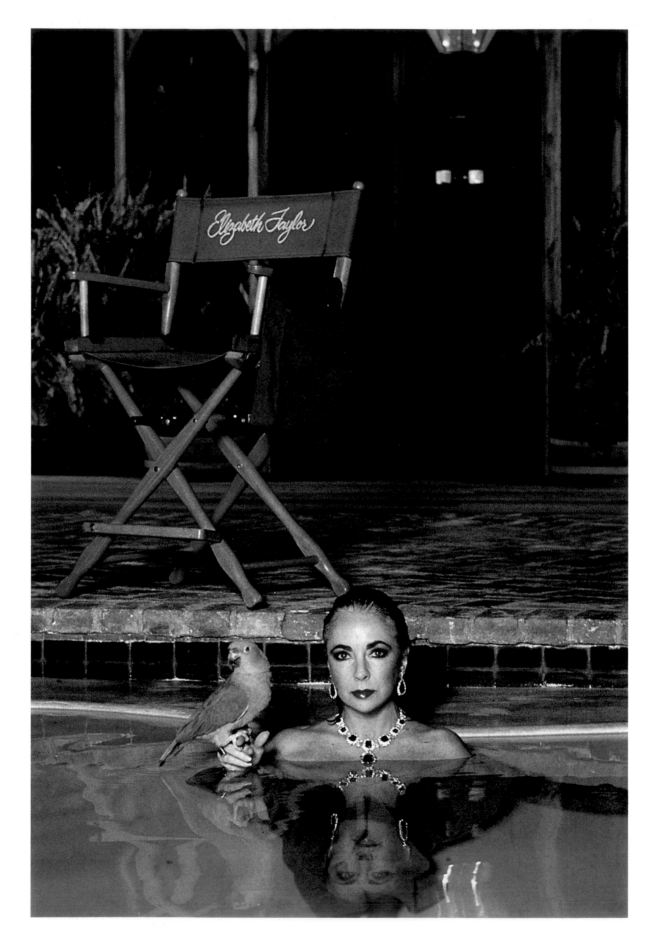

38 Elizabeth Taylor, Los Angeles 1985

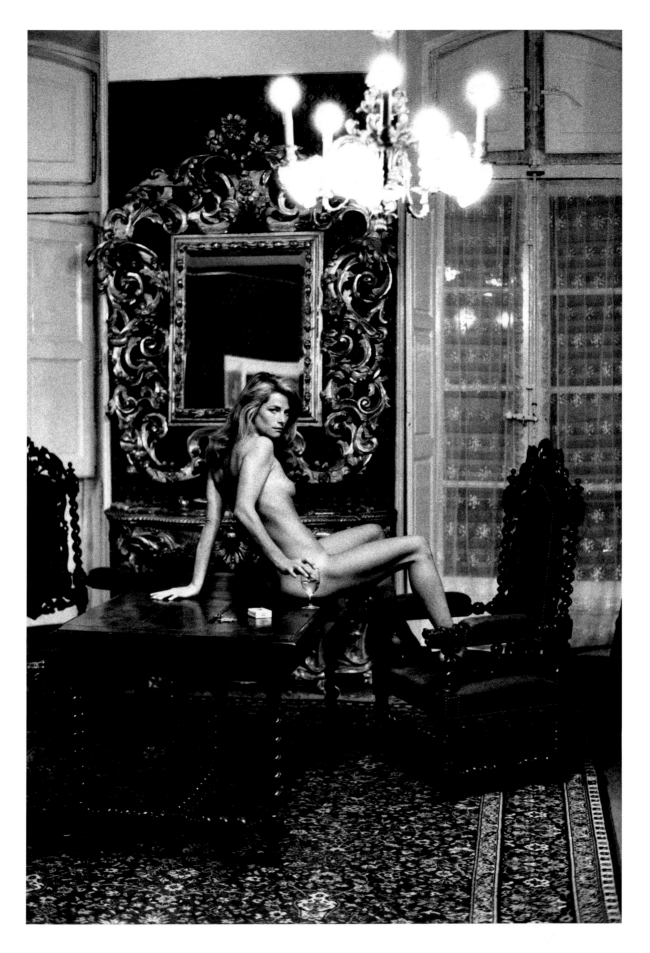

39 Charlotte Rampling, Hotel Nord-Pinus, Arles 1973

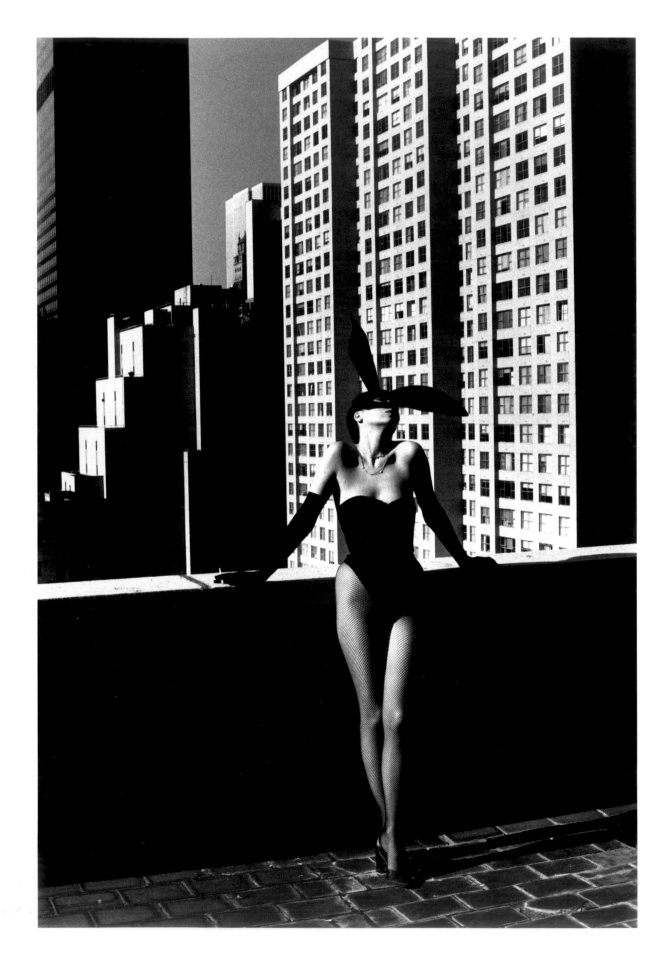

40 Elsa Peretti, New York 1975

41 Helmut Kohl, Bonn 1990

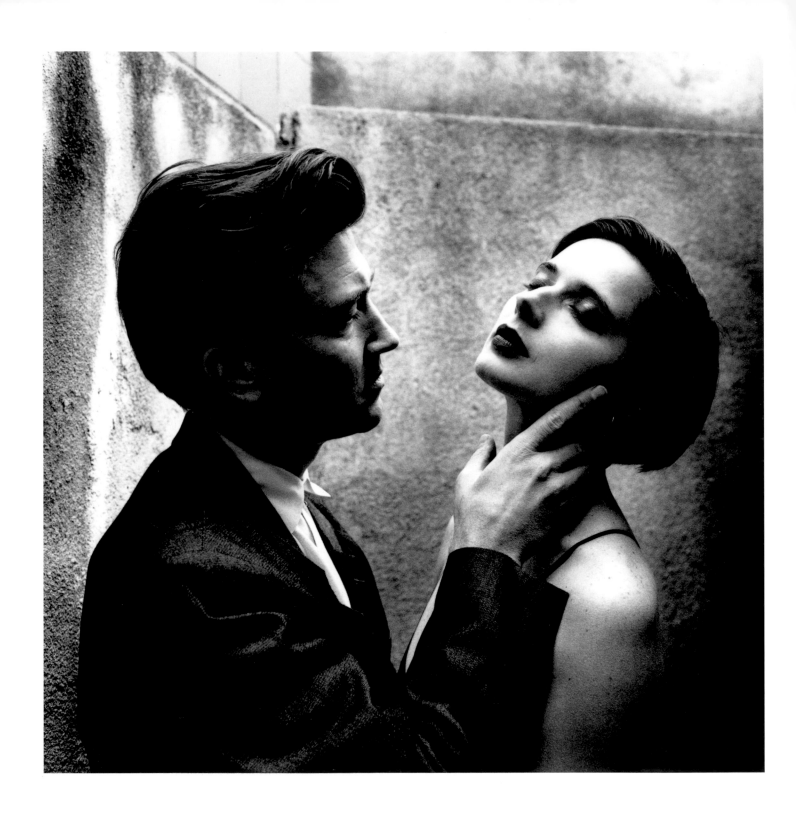

42 David Lynch and Isabella Rossellini, Los Angeles 1992

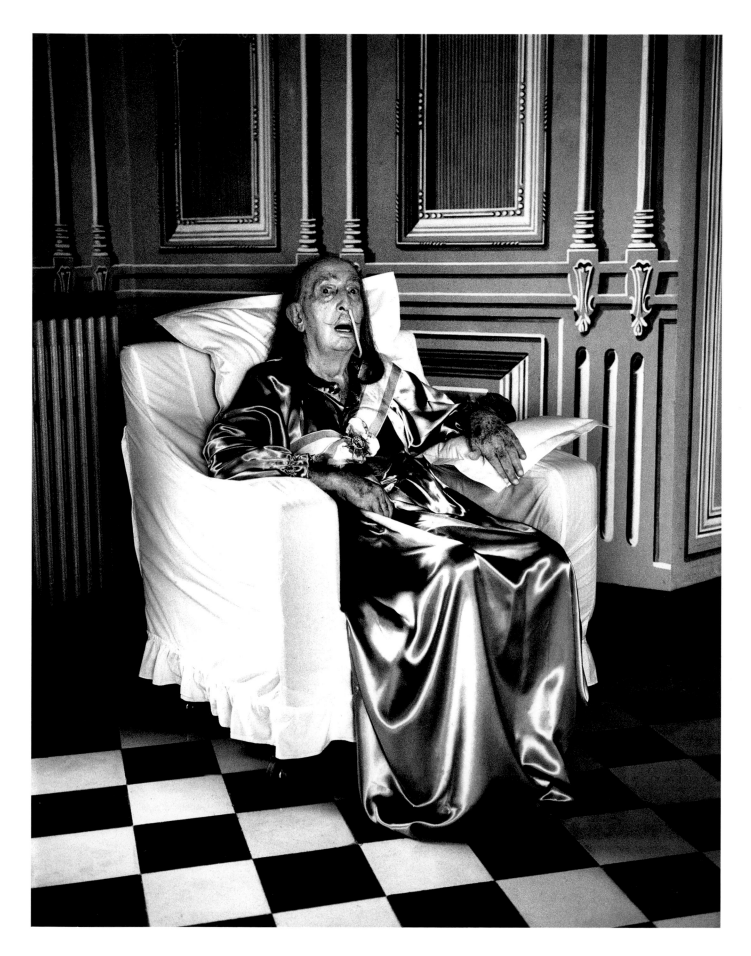

43 Salvador Dalí, Figueras 1986

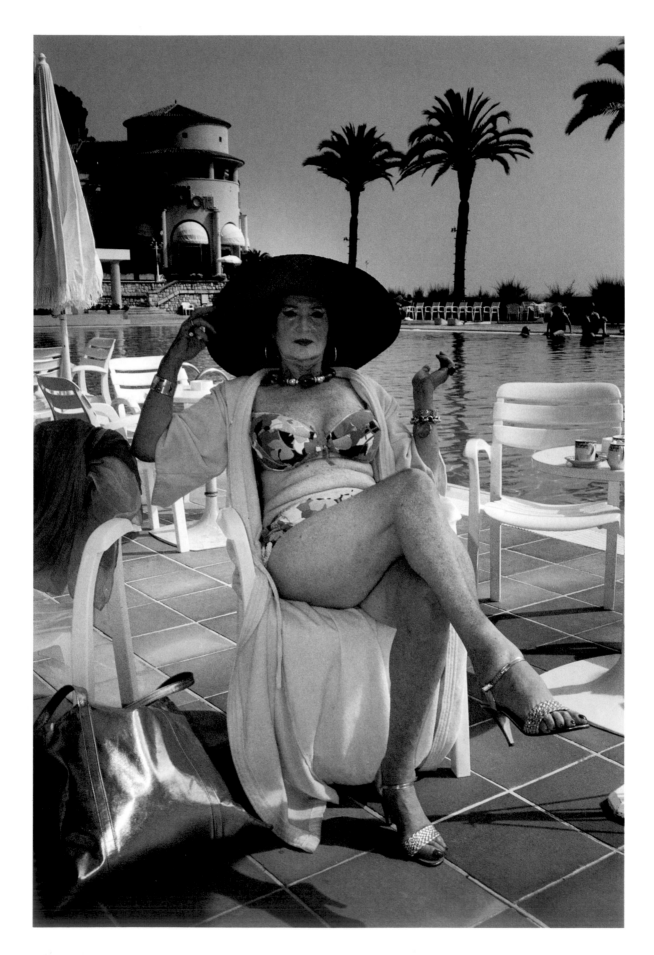

44 Frau Sauer, Monte Carlo Beach Hotel, 1989

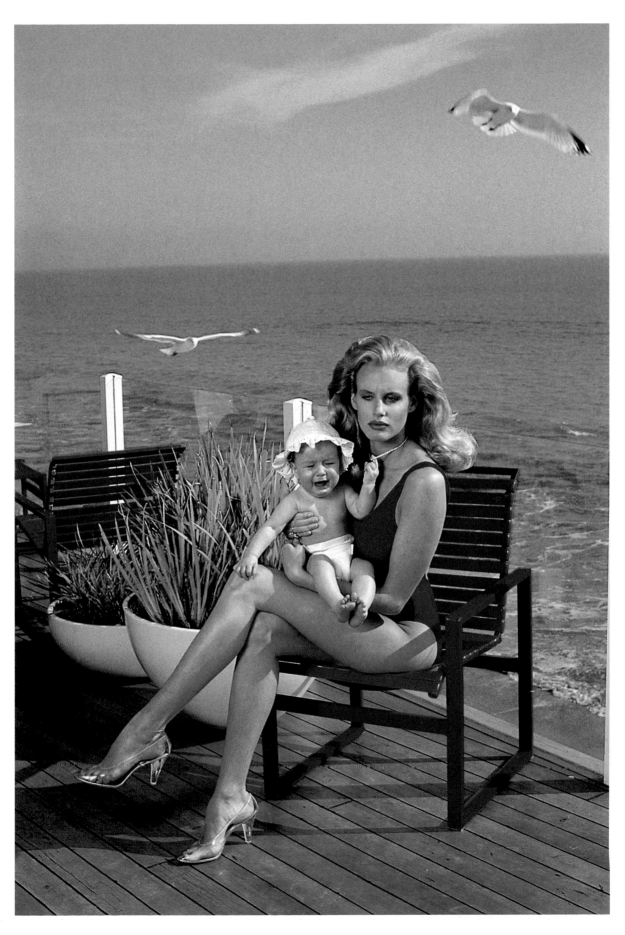

45 Daryl Hannah with unidentified baby, Los Angeles 1984

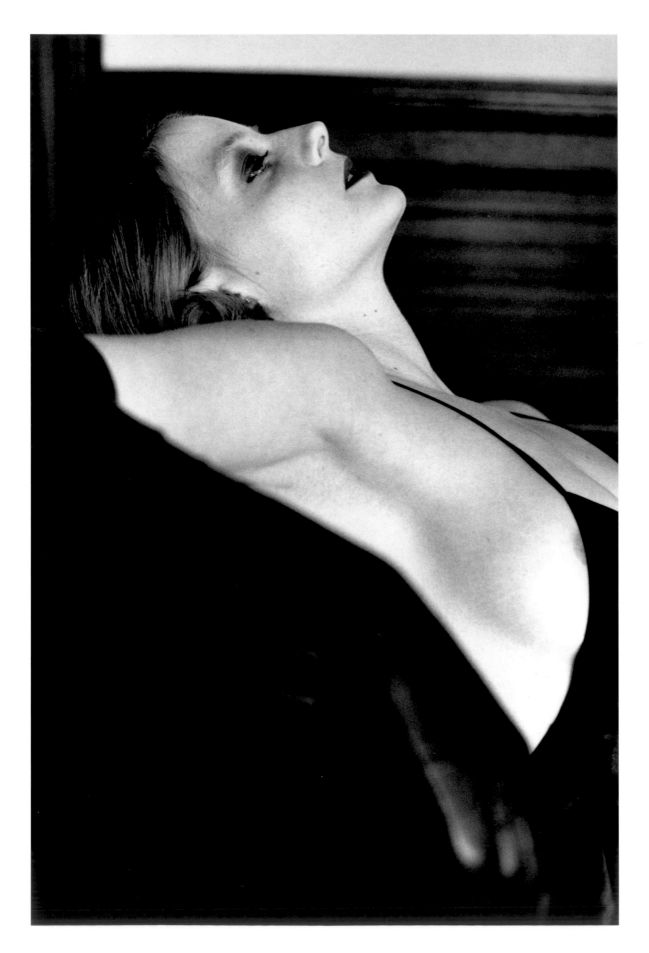

46 Jodie Foster, Hollywood 1987

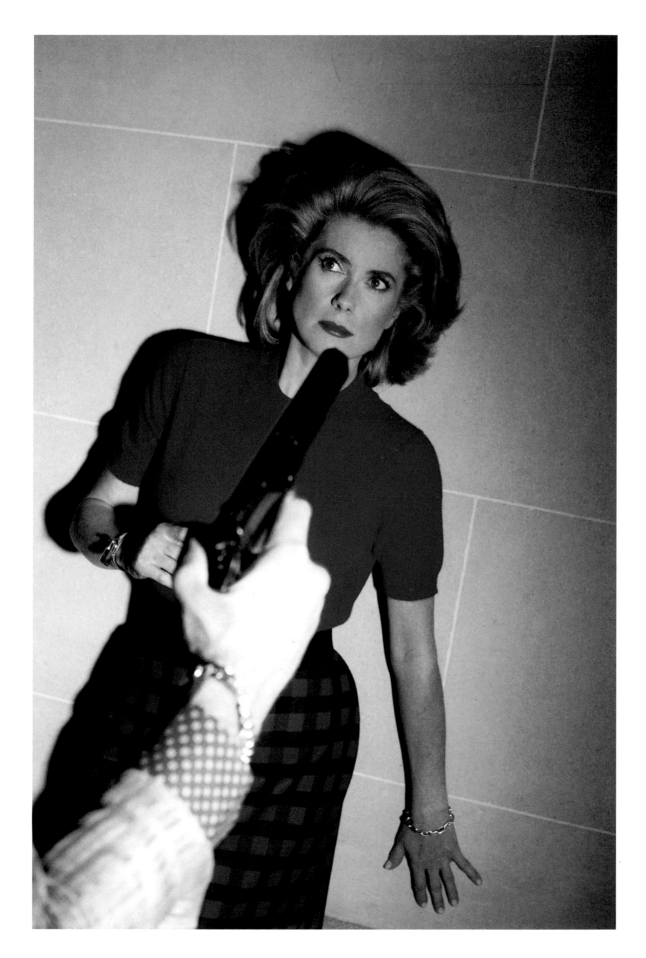

47 Catherine Deneuve for a photo-essay in "Nouvel Observateur", 1983

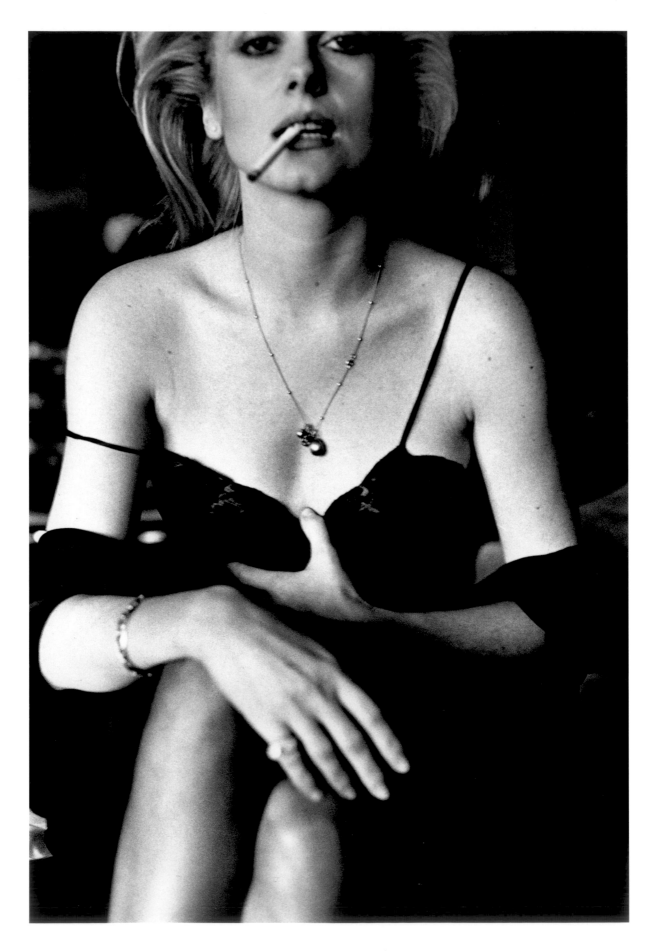

48 Catherine Deneuve, Paris 1976

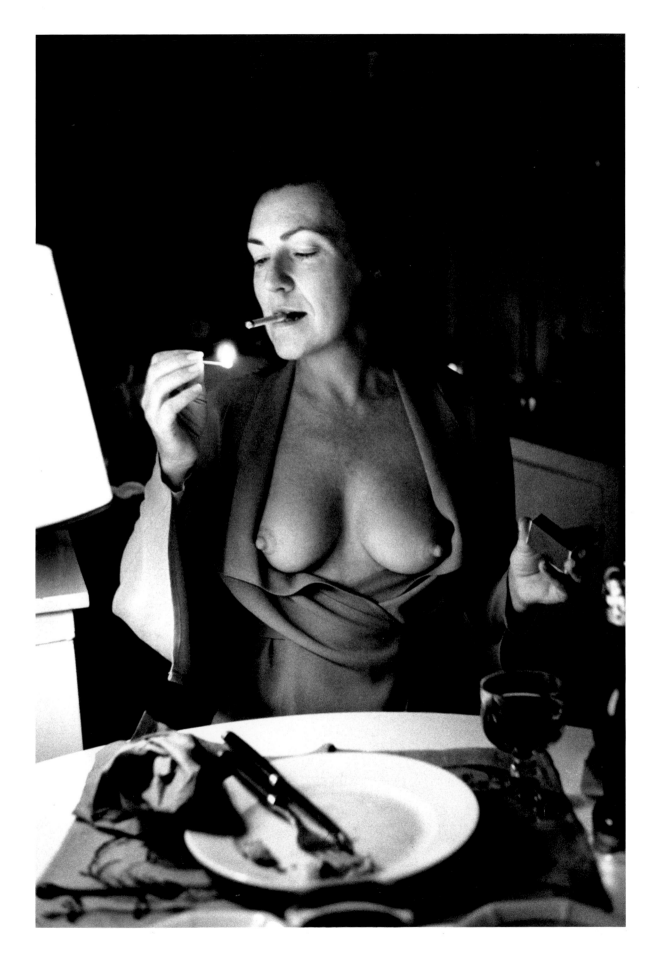

49 June Newton, Paris 1972

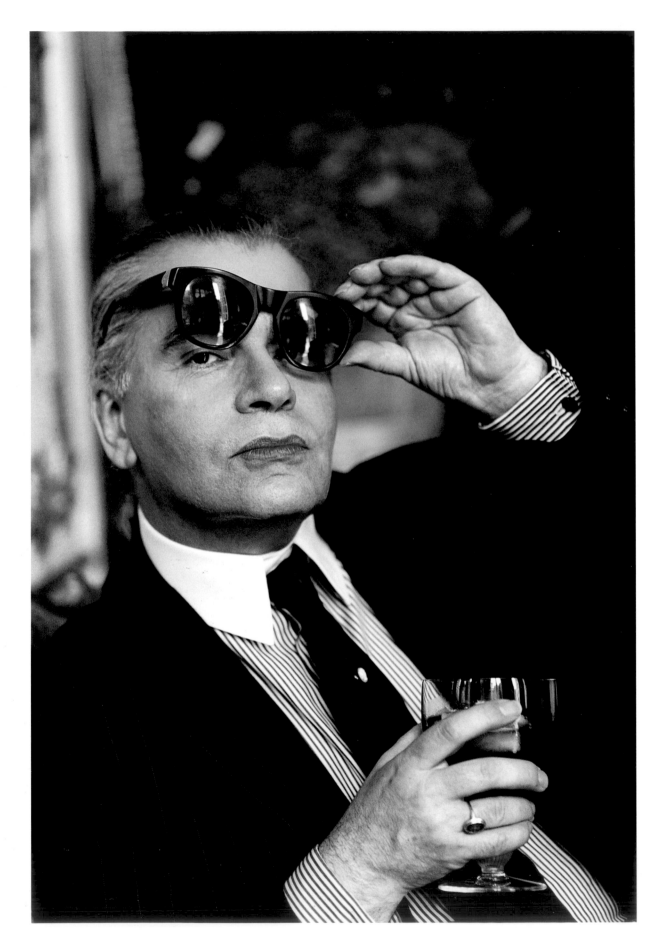

50 Karl Lagerfeld, 1992

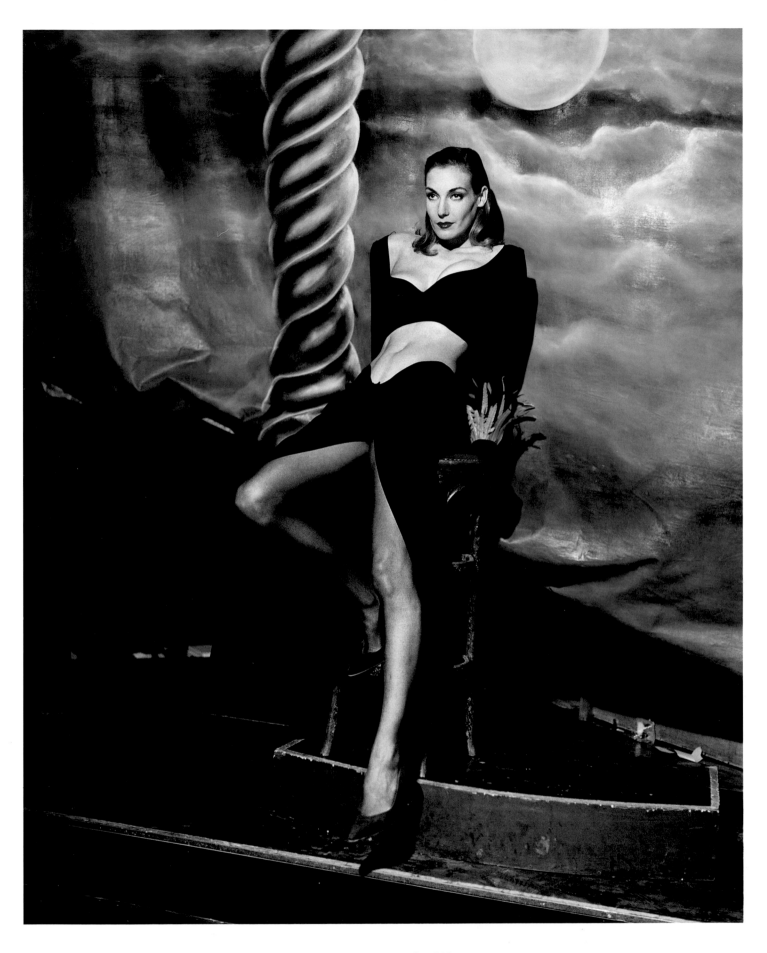

51 Ute Lemper, Paris 1989

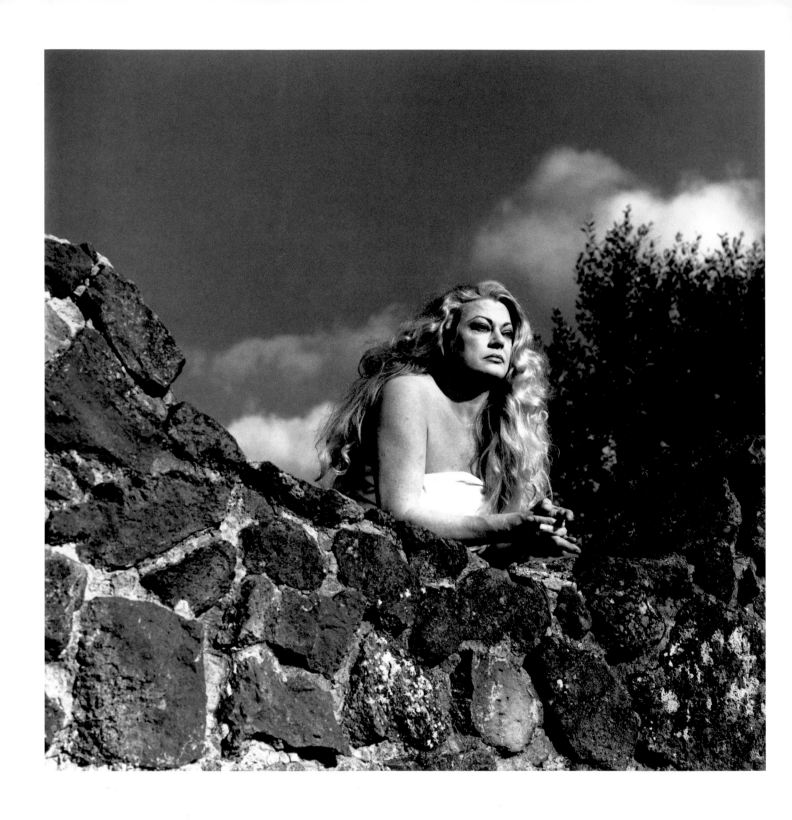

52 Anita Ekberg in her garden, Genzano 1988

53 Leni Riefenstahl, near Munich 1992

54 The two Jesuses, Oberammergau 1990

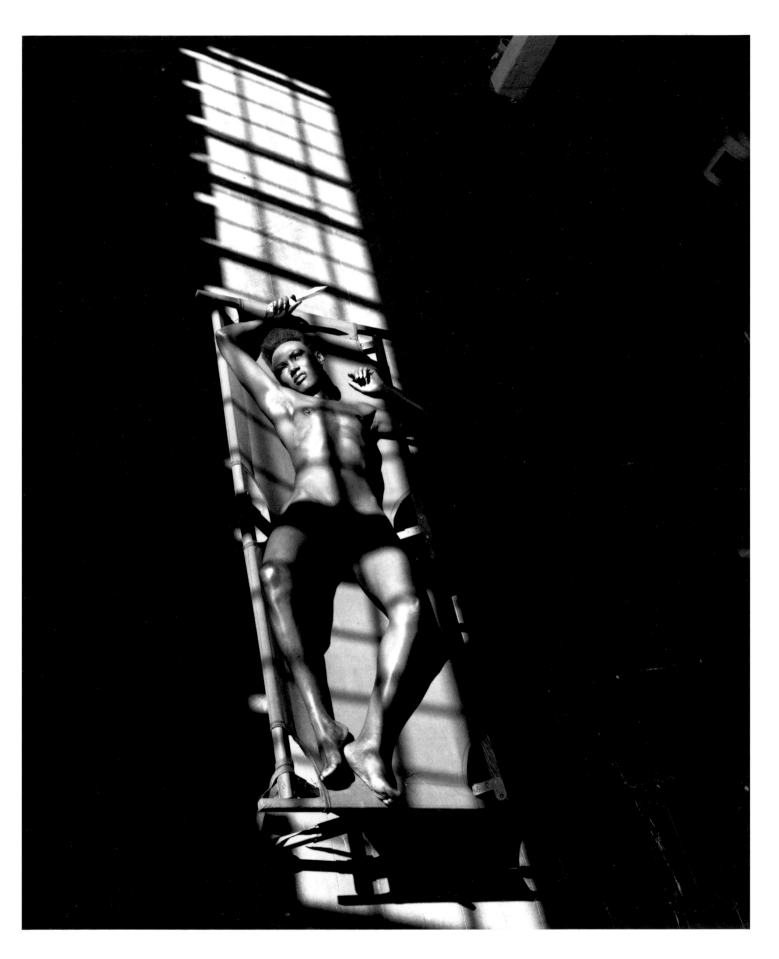

55 Grace Jones, Los Angeles 1985

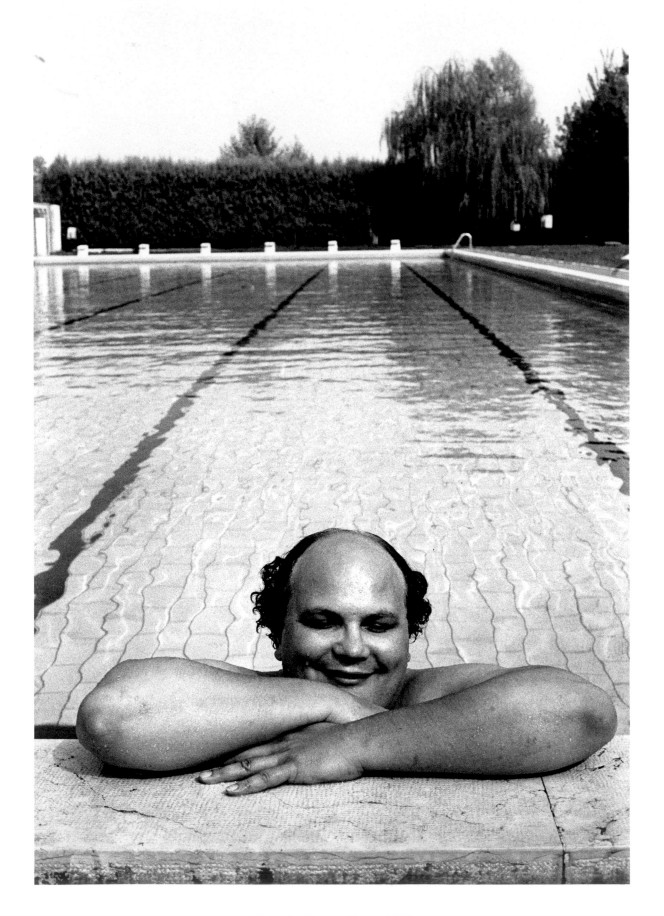

56 Xavier Moreau, Verona 1979

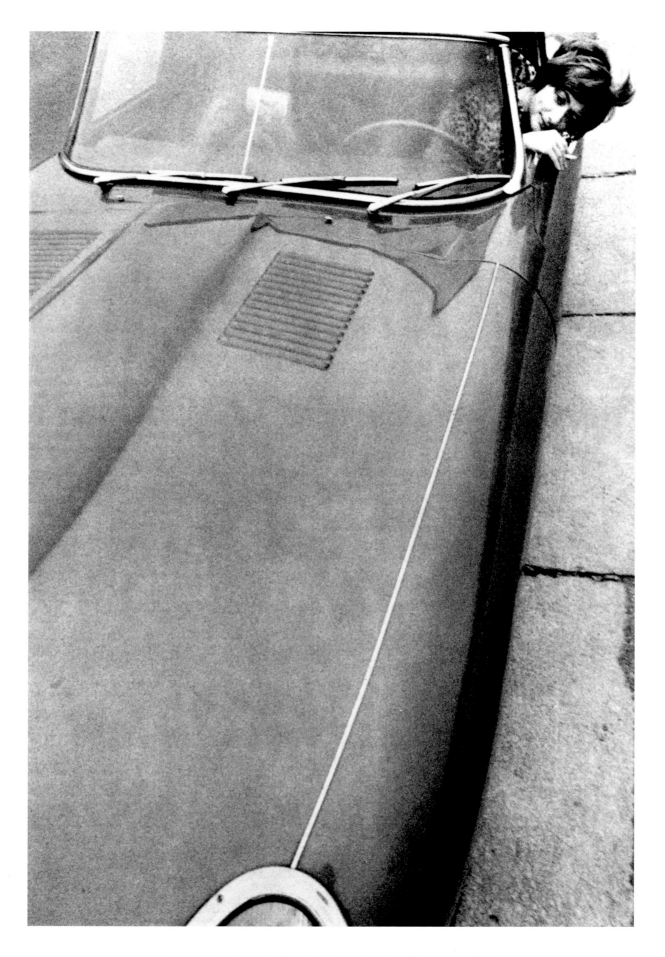

57 Françoise Sagan, "Adam" magazine, Condé Nast, Paris 1963

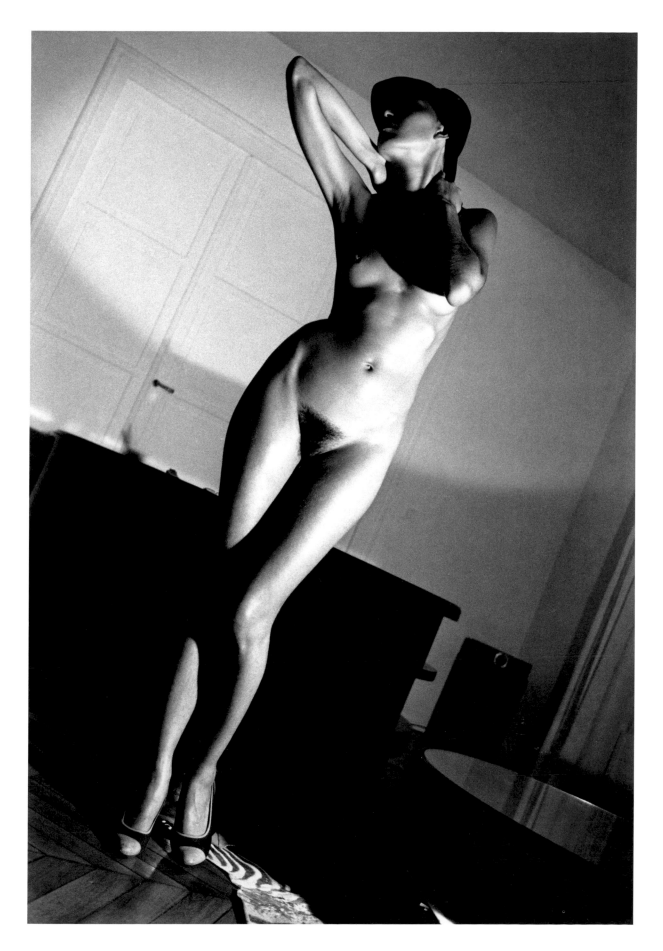

58 Jenny Kapitän, Paris 1978

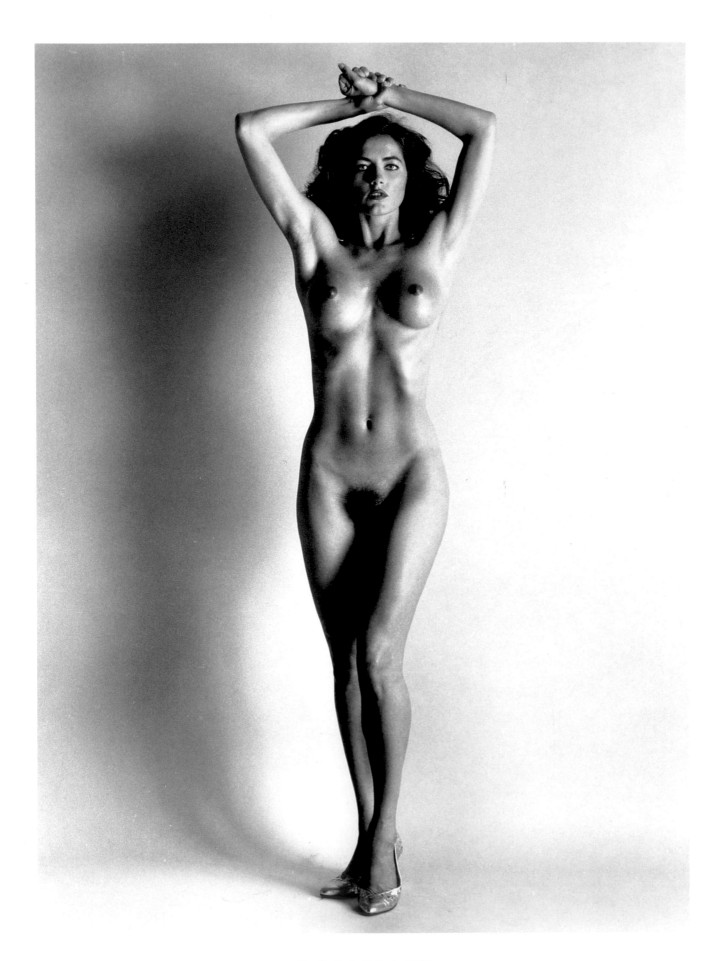

59 Big Nude V, Paris 1980

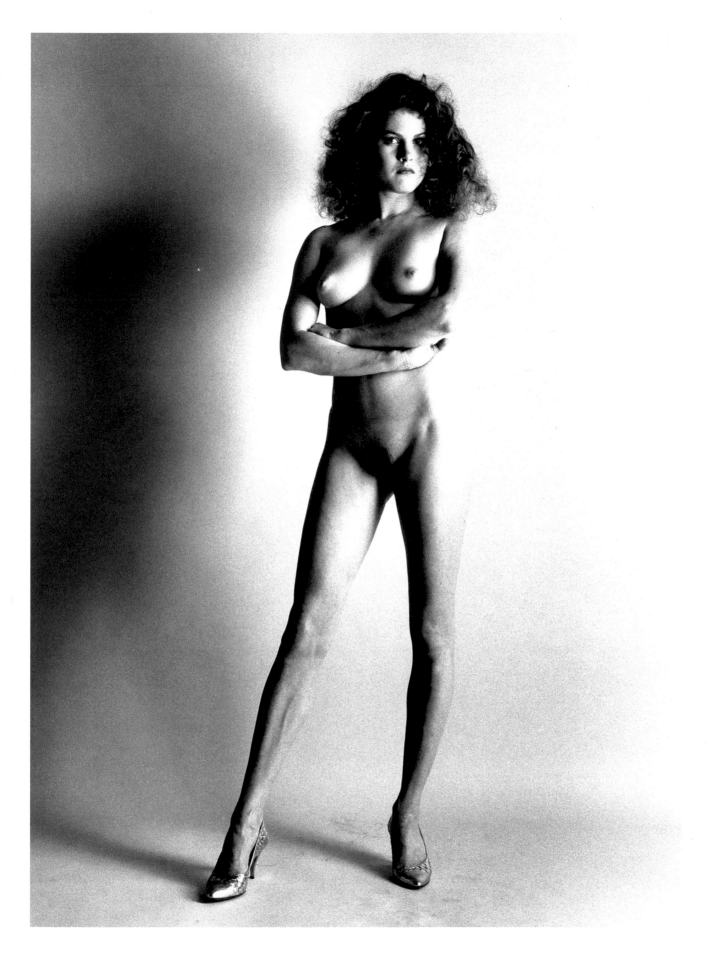

60 Big Nude II, Paris 1980

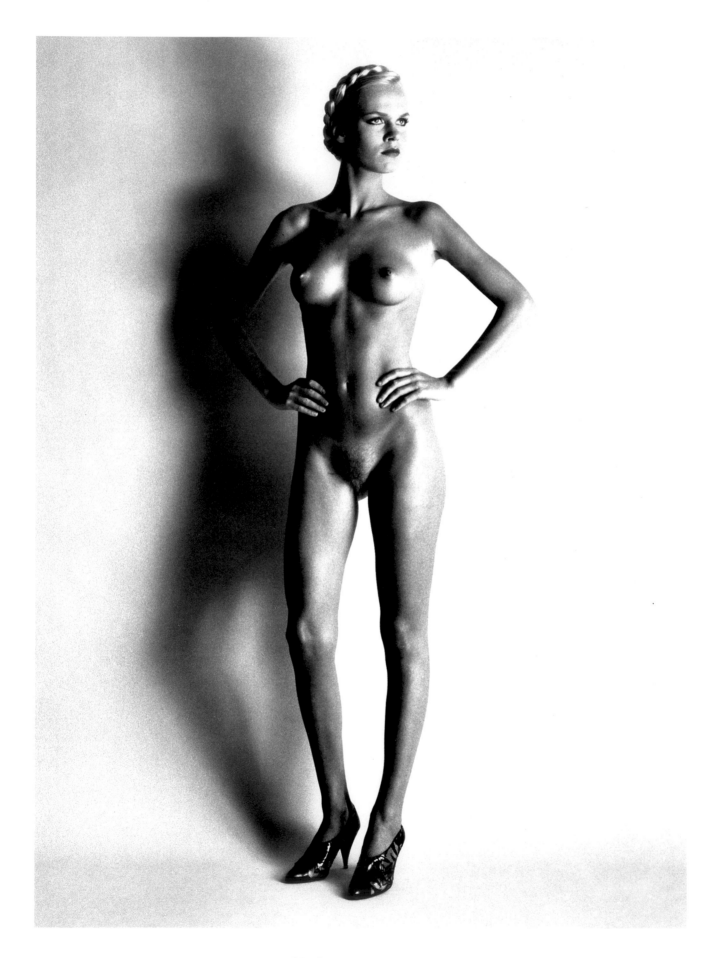

61 Big Nude I, Paris 1980

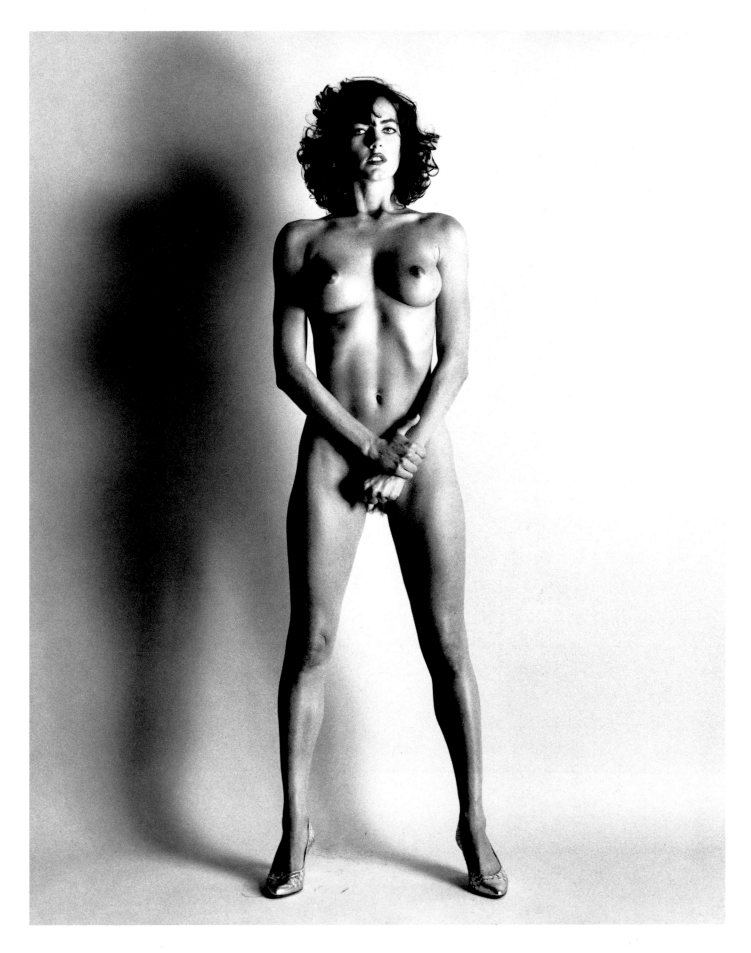

62 Big Nude III, Paris 1980

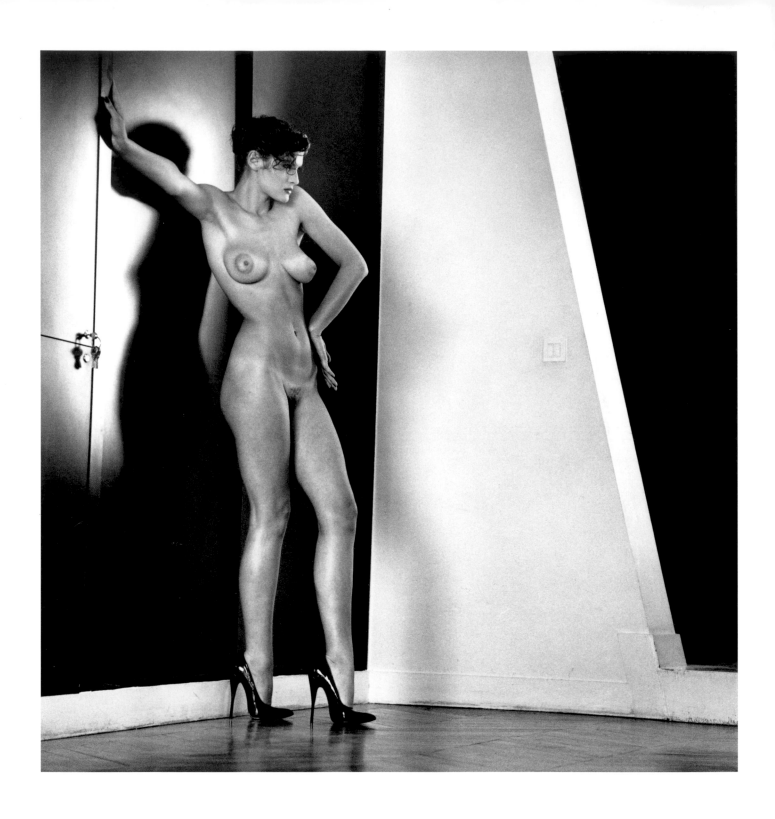

63 Sylvia in my studio, Paris 1981

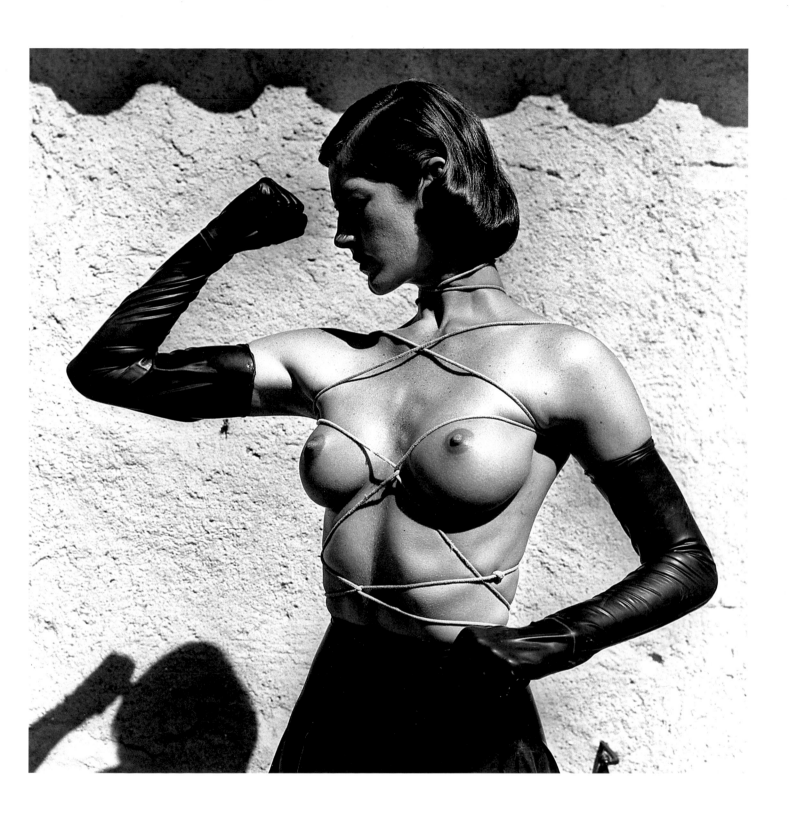

64 Tied-up torso, Ramatuelle 1980

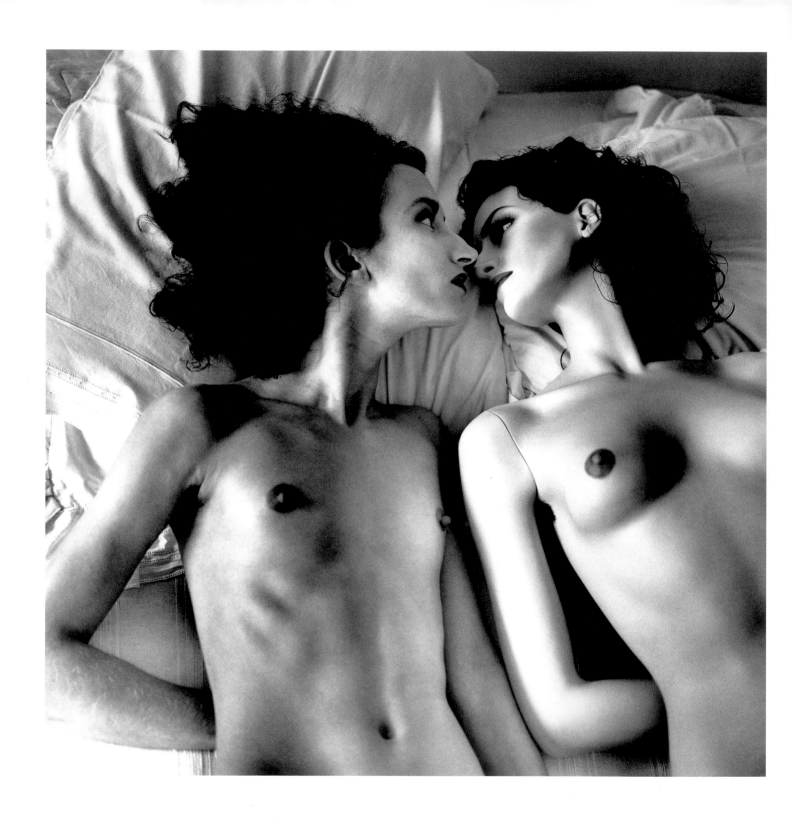

65 The 2 Violettas in bed, Paris 1981

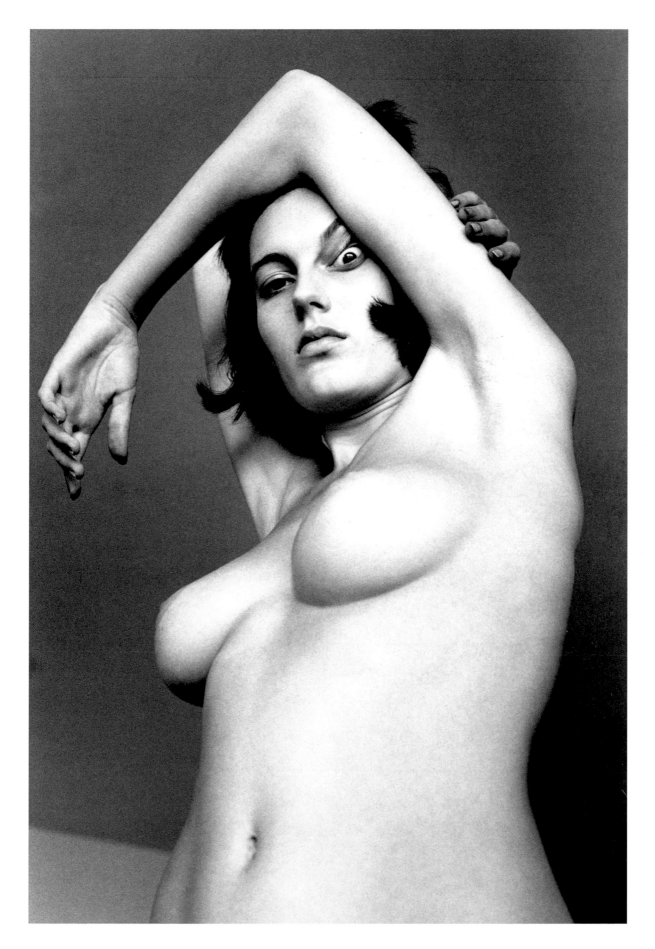

66 Arielle, Monte Carlo 1982

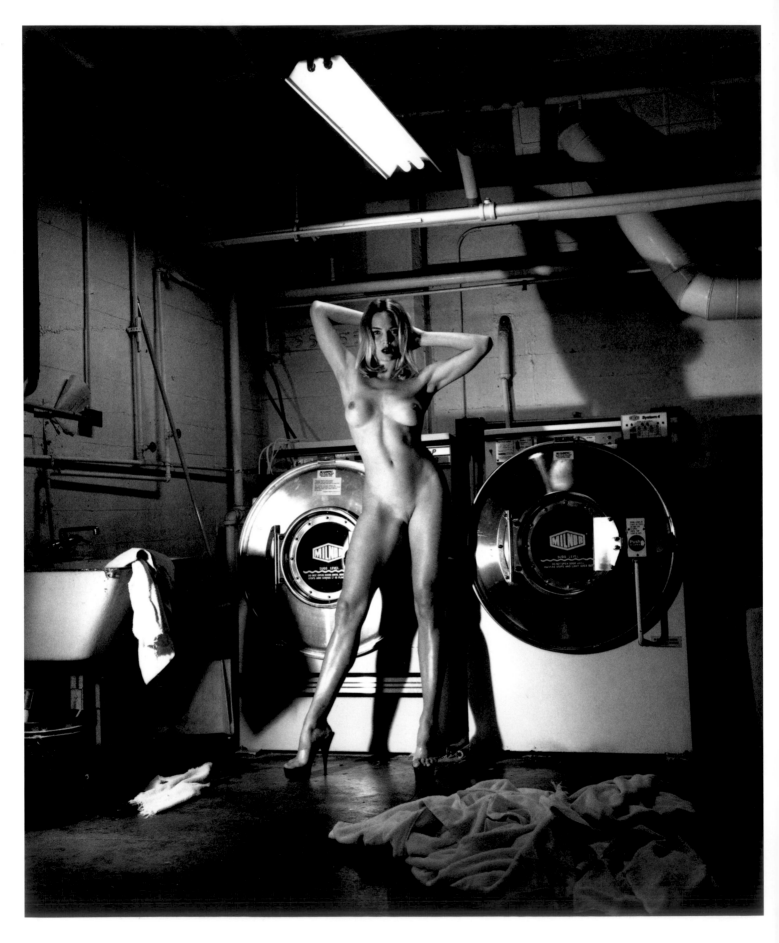

67 Domestic Nude III – In the laundry room, Hollywood 1992

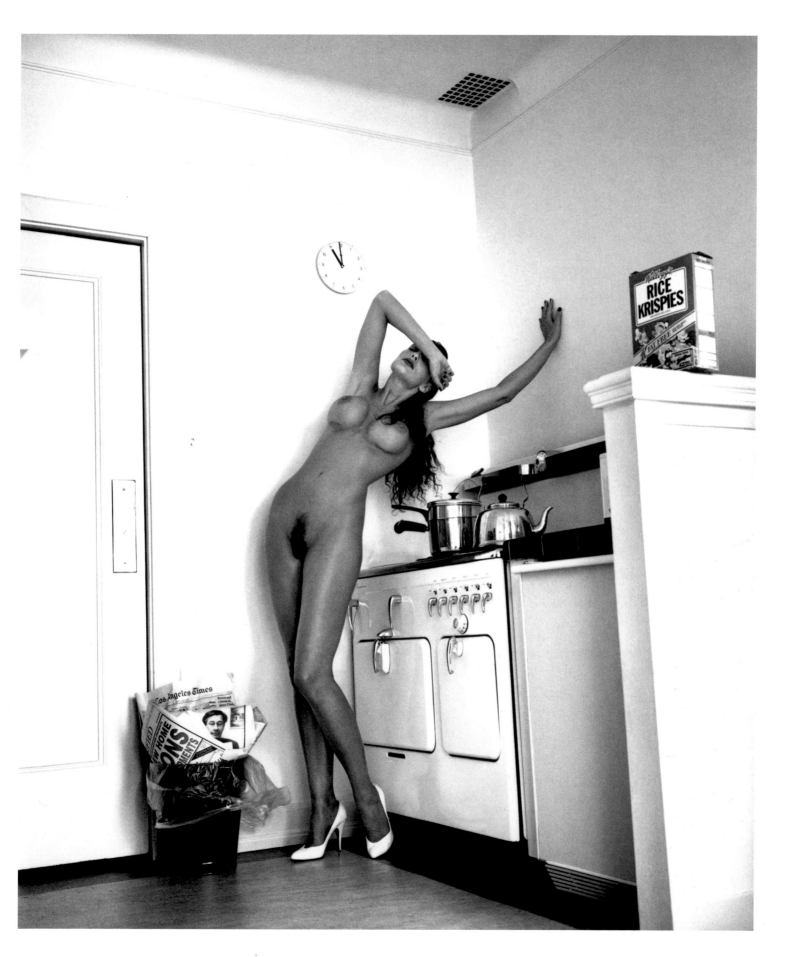

68 Domestic Nude I – In my kitchen, Hollywood 1992

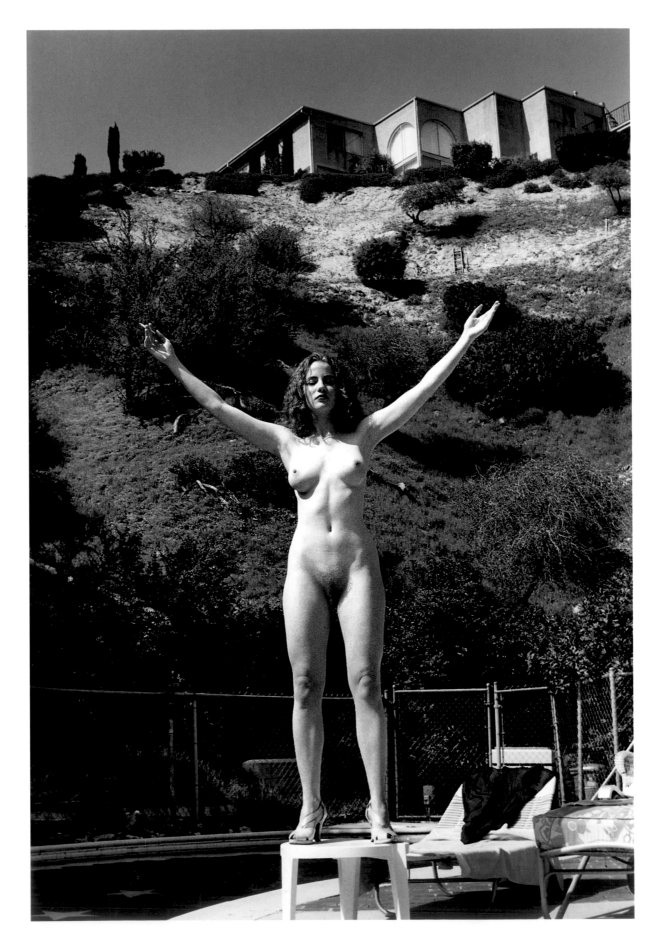

69 Domestic Nude IX – The Redhead, Los Angeles 1992

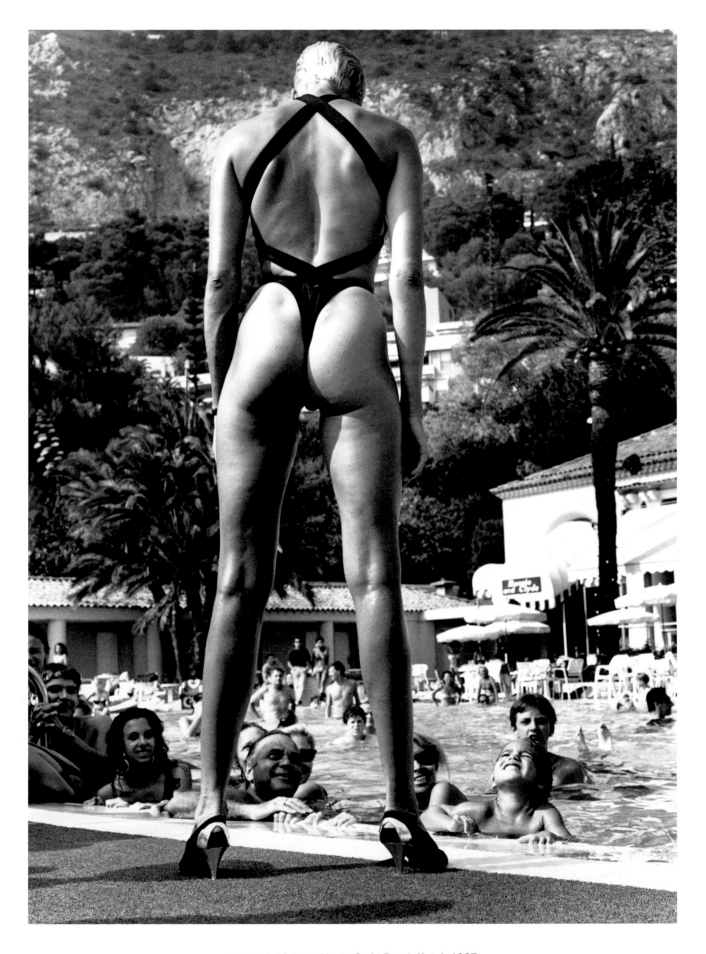

70 Birgit Nielsen, Monte Carlo Beach Hotel, 1987

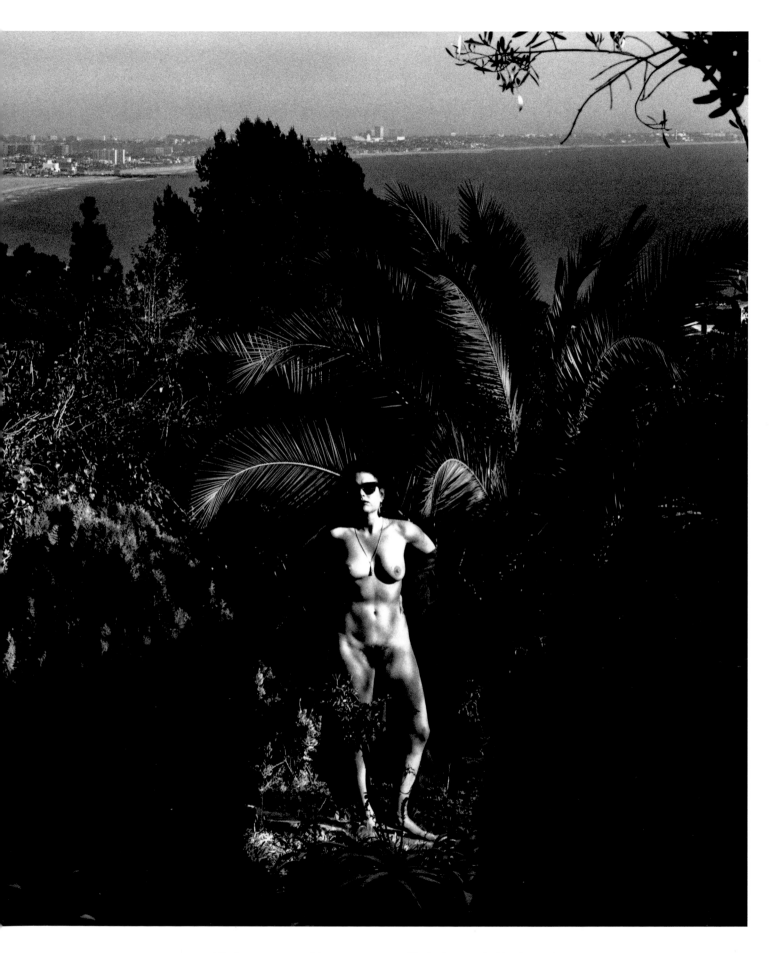

71 Renata Pompelli in her garden, Pacific Palisades, California 1990

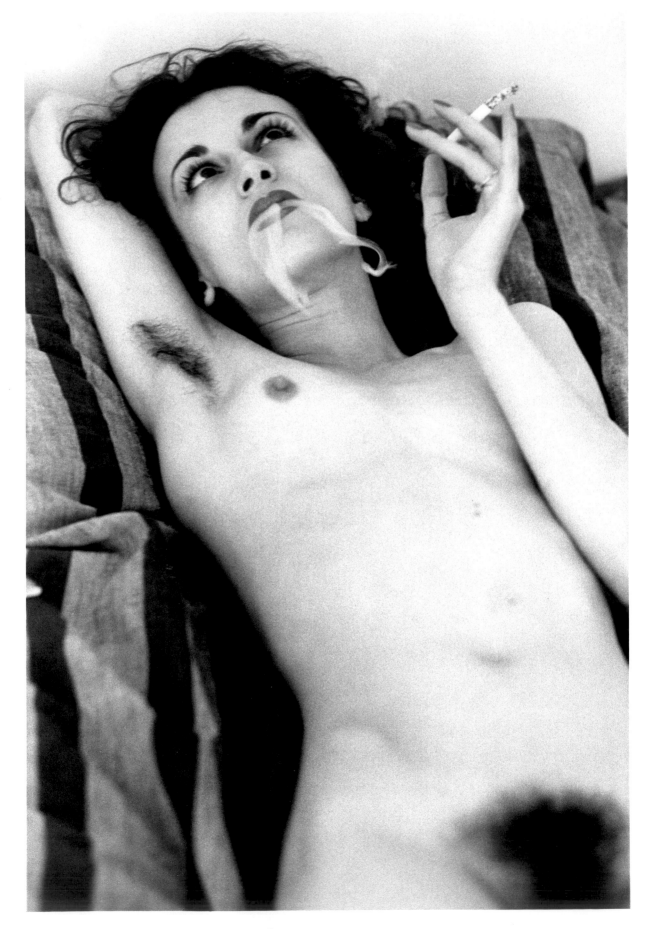

72 Violetta Sanchez, Paris 1979

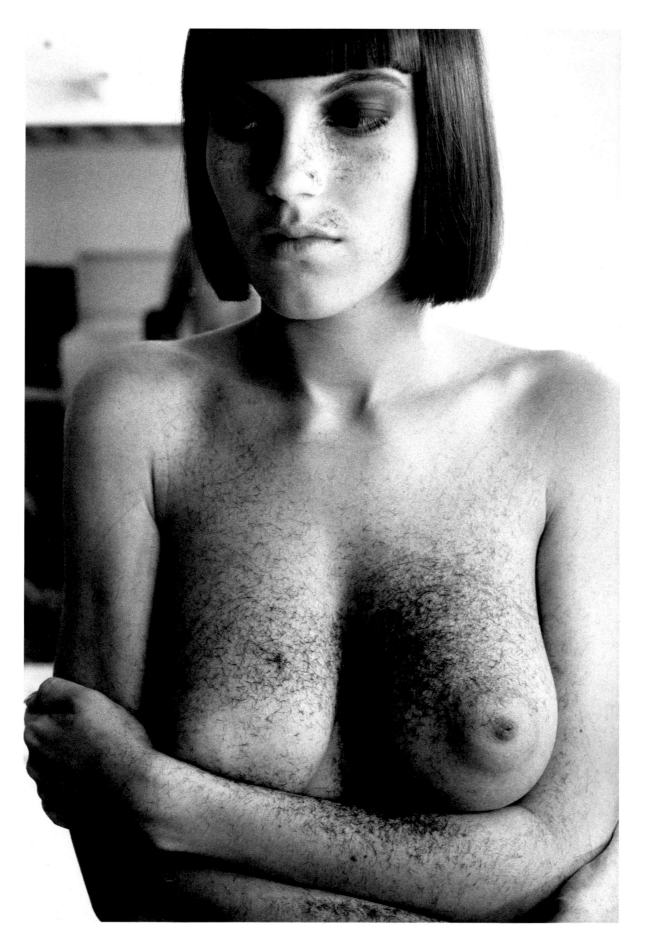

73 Arielle after a haircut, Paris 1982

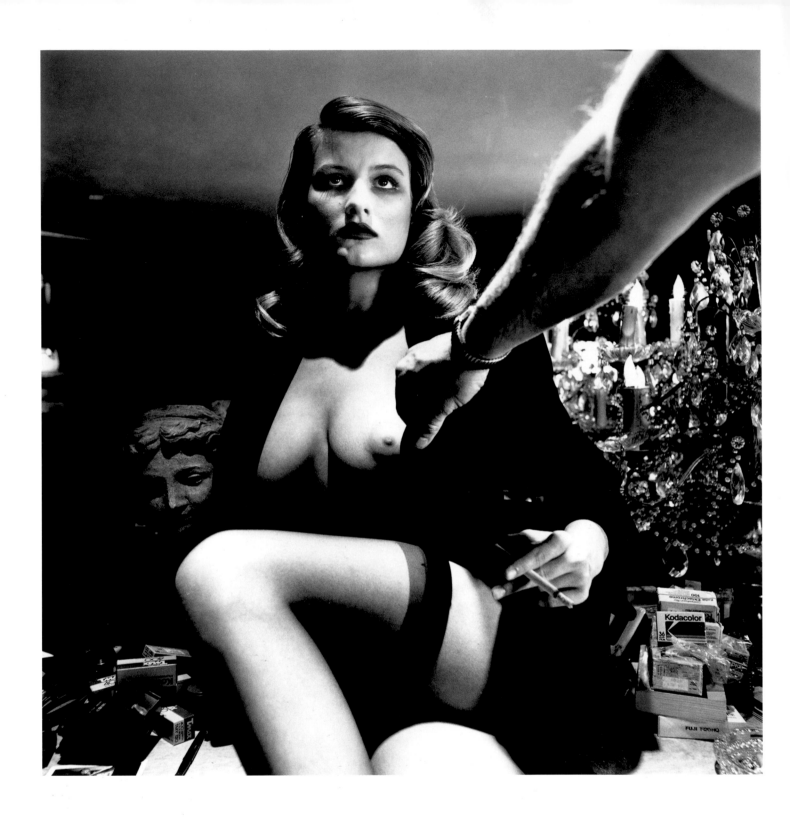

74 Study for voyeurism, Los Angeles 1989

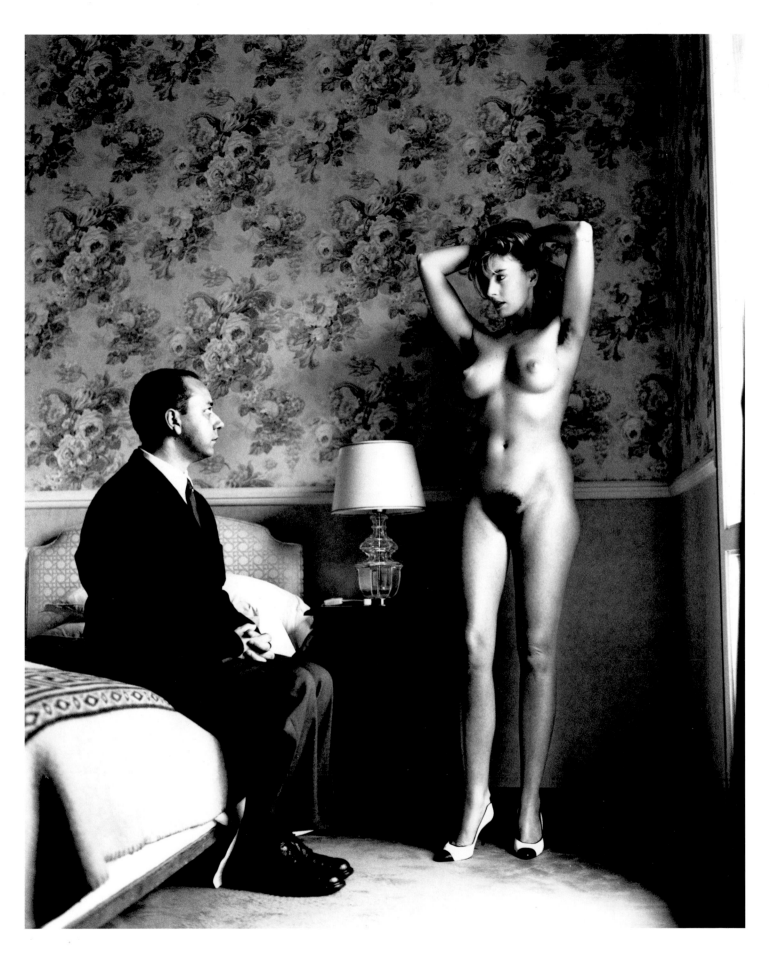

75 In my hotel room, Montecatini 1988

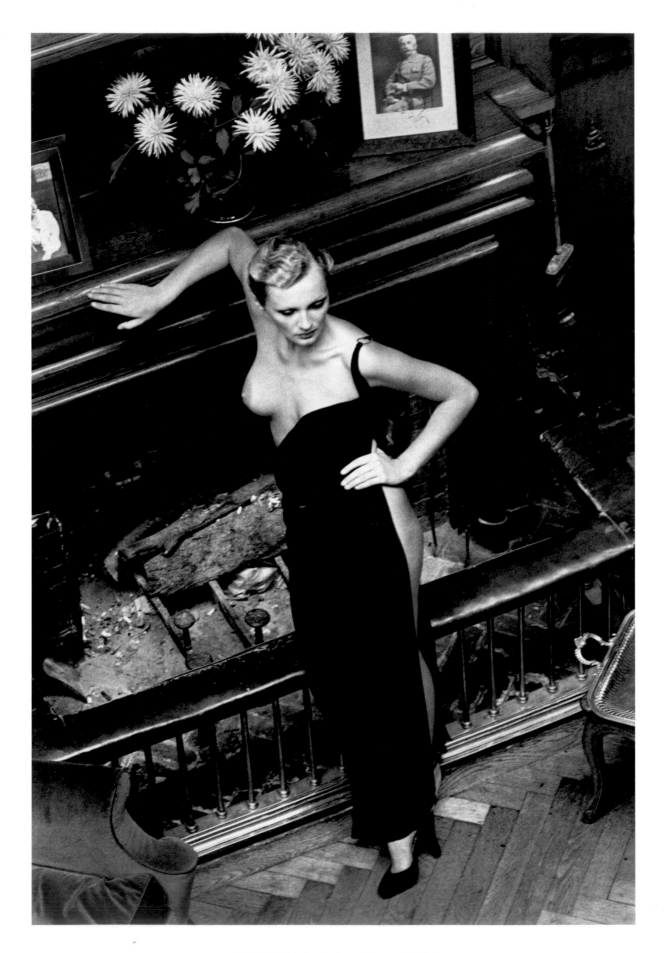

76 Roselyne, Arcangues, France 1974

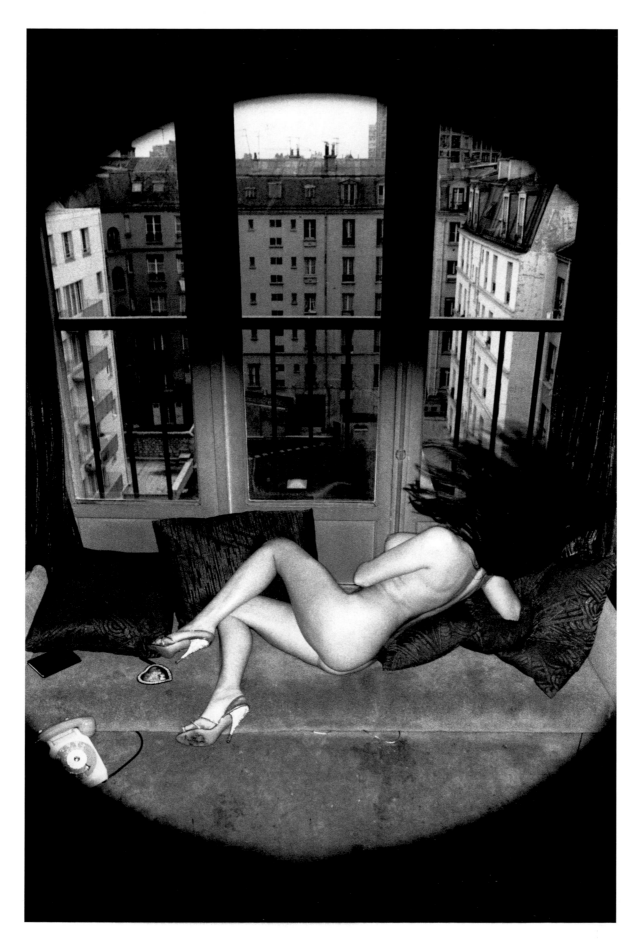

77 Suzy at home, Paris 1974

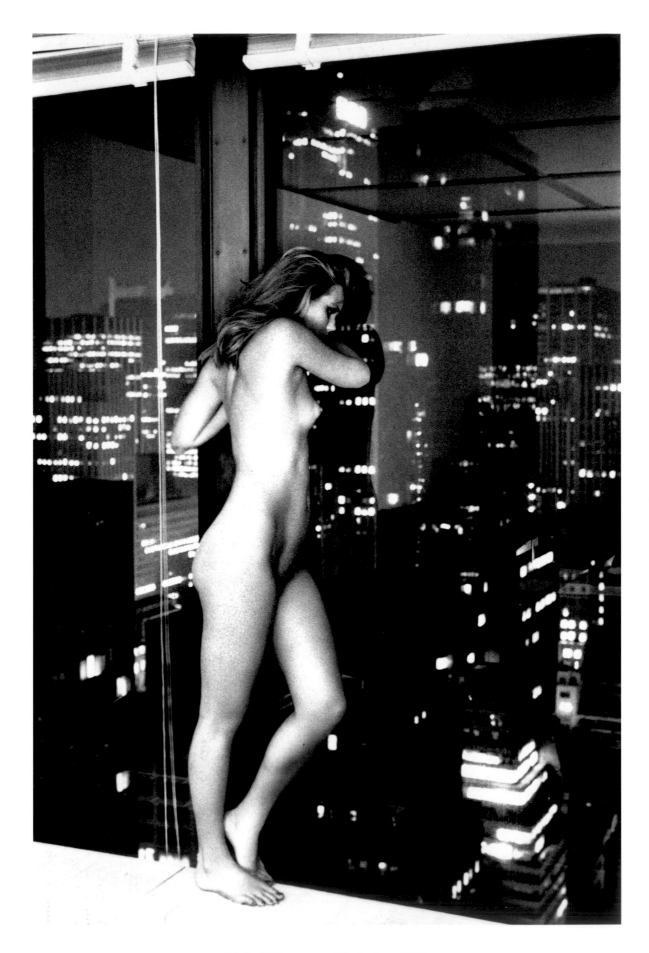

78 Patti Hansen over Manhattan, 1977

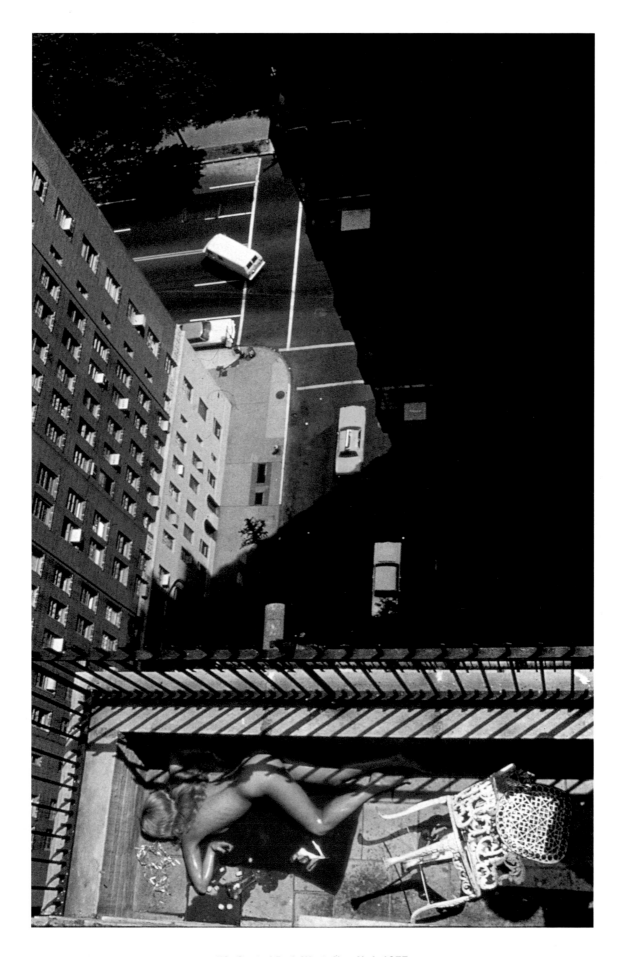

79 Central Park West, New York 1977

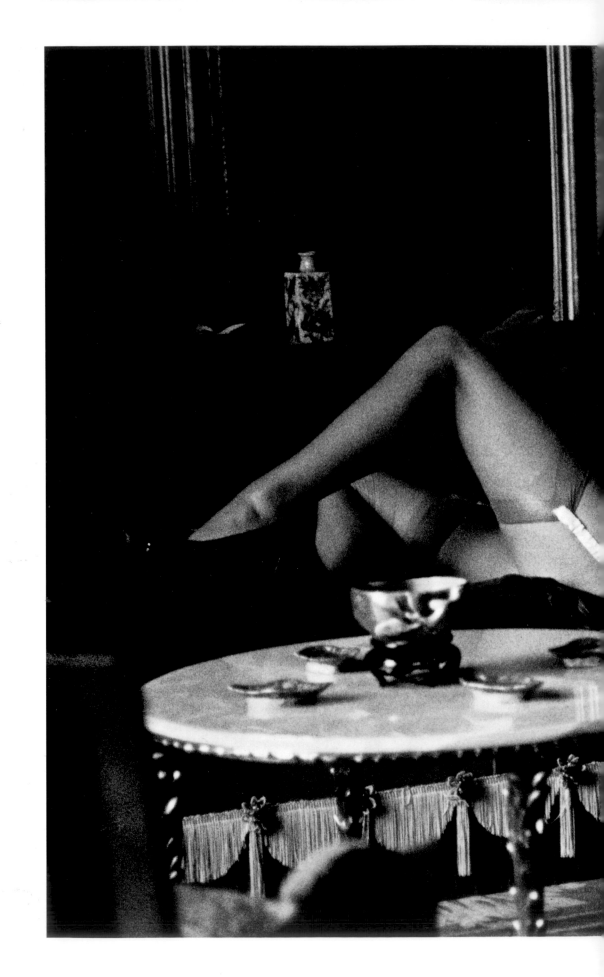

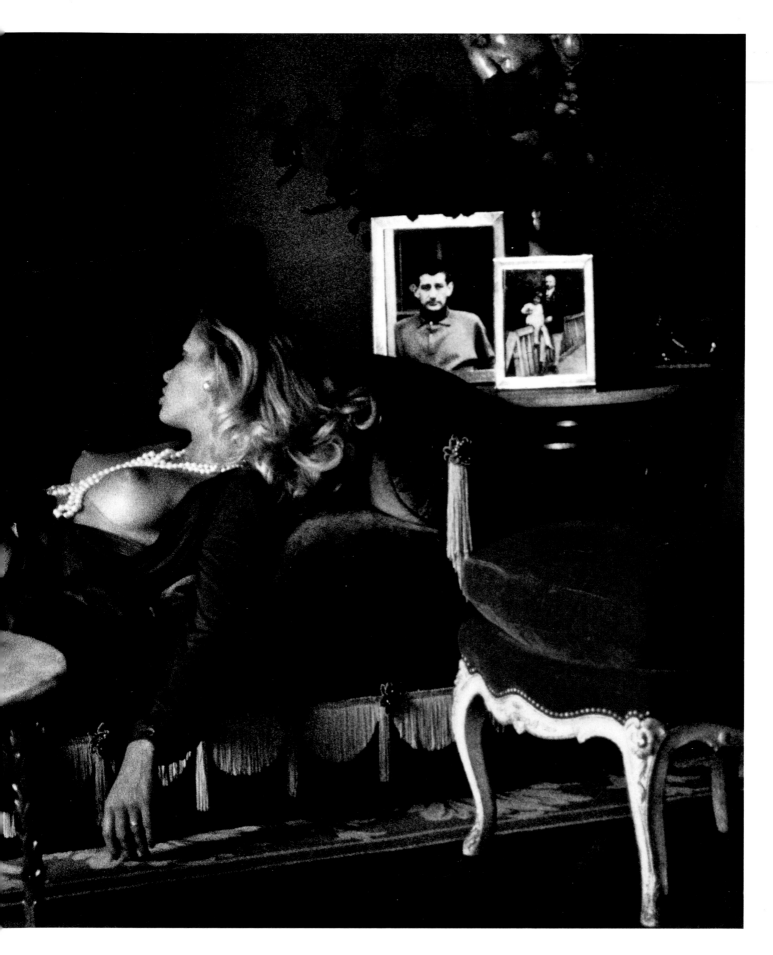

80 "La Bourgeoise", Paris 1974

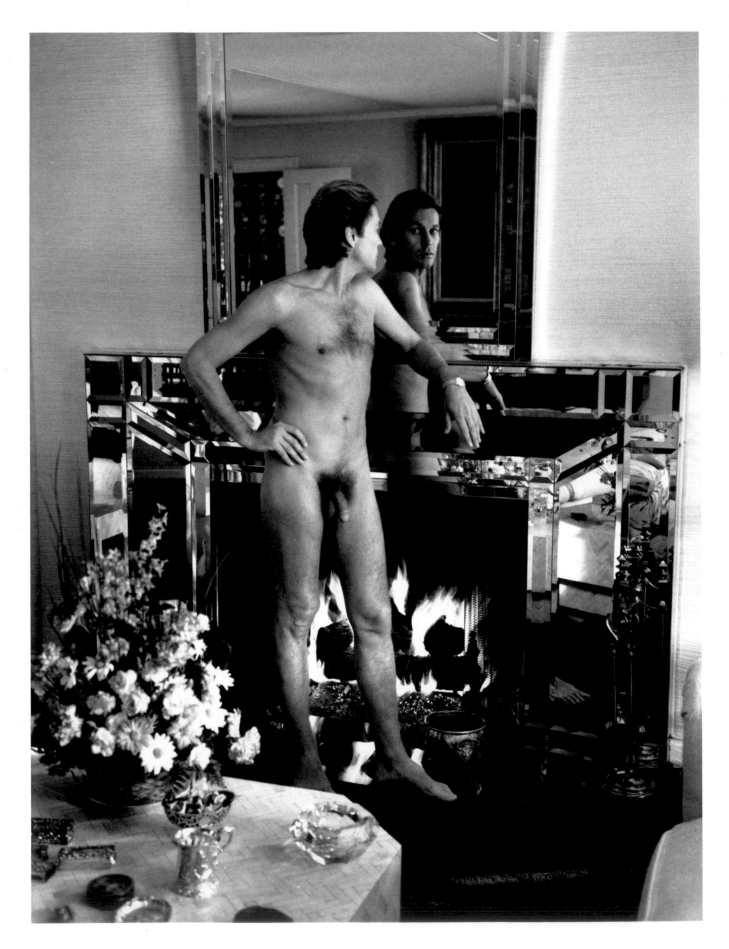

81 Helmut Berger, Beverly Hills 1984

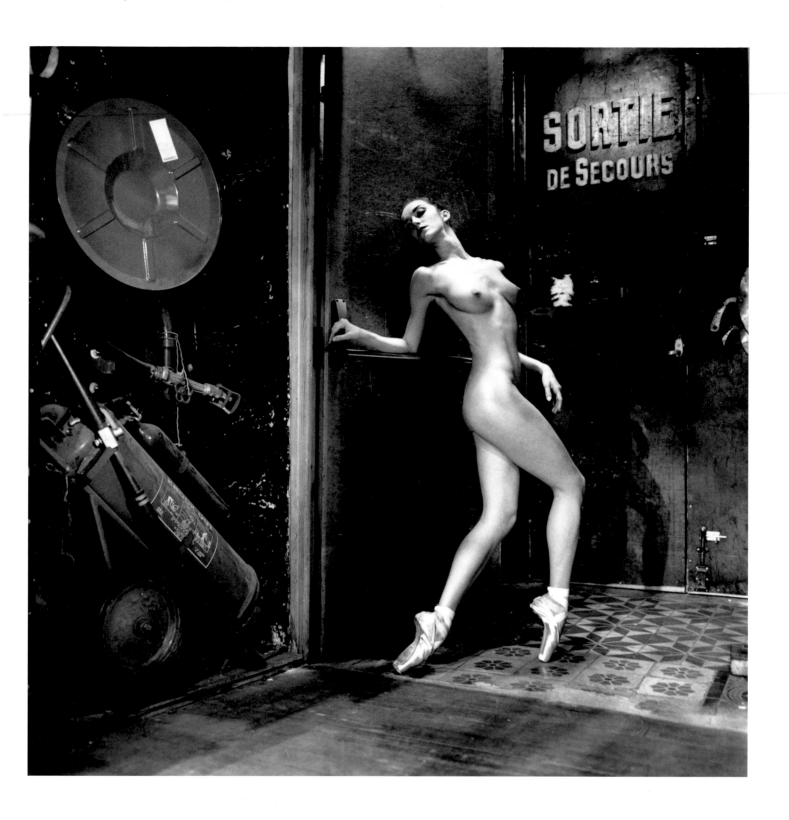

82 Bernice Coppieters, soloist, Ballets de Monte Carlo, 1992

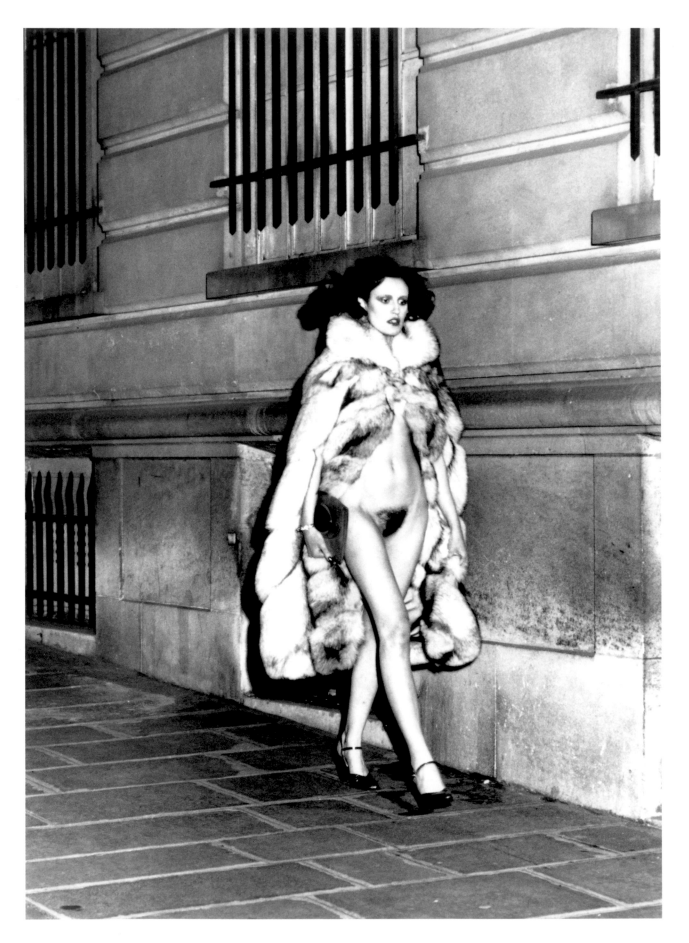

83 Laura in a fox cape, Avenue Georges V, Paris 1974

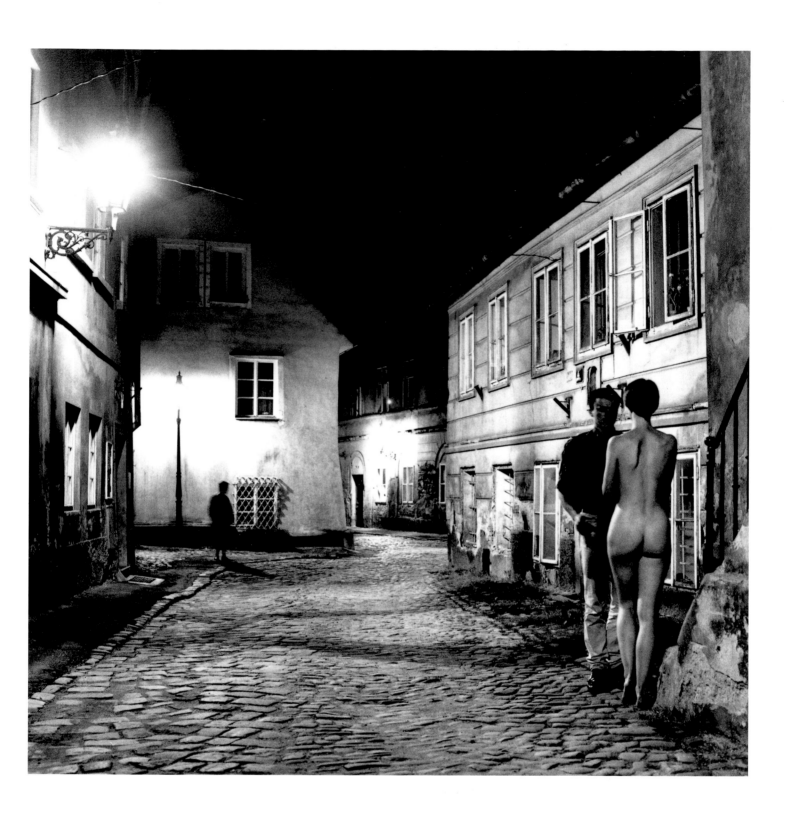

84 In the New World, Prague 1988

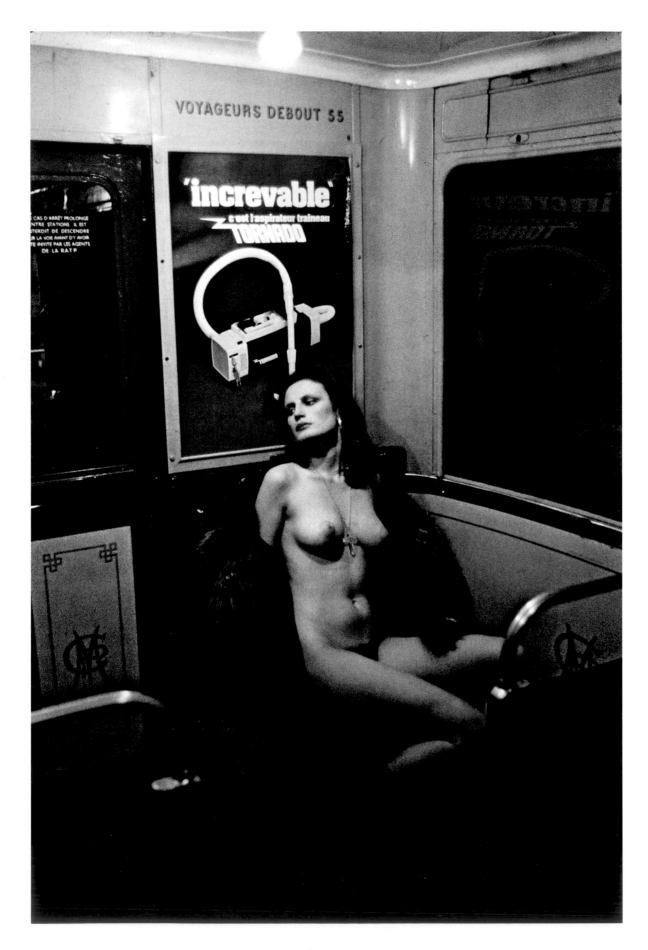

85 In the Paris Metro, "Oui" magazine, 1974

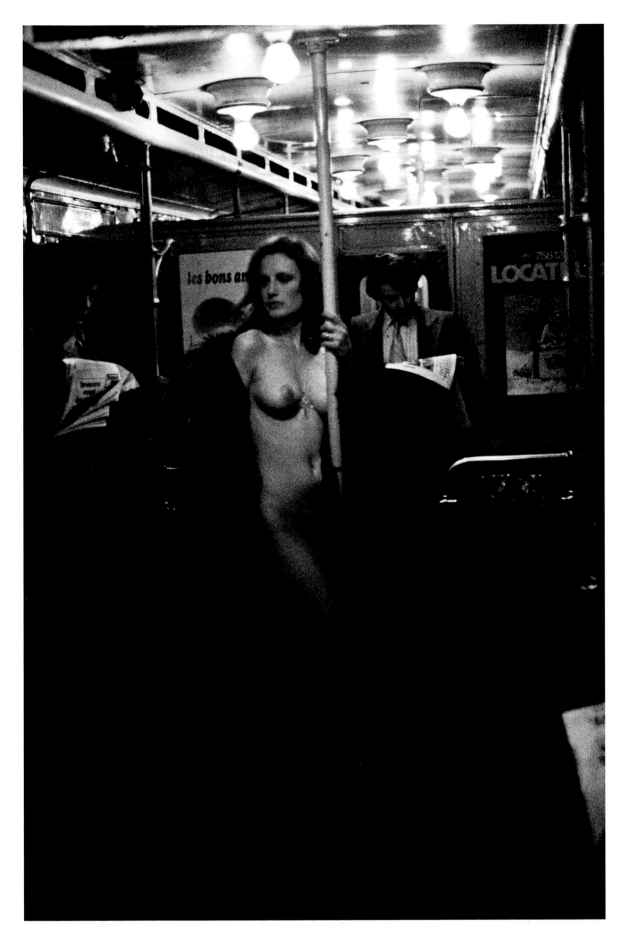

86 In the Paris Metro, "Oui" magazine, 1974

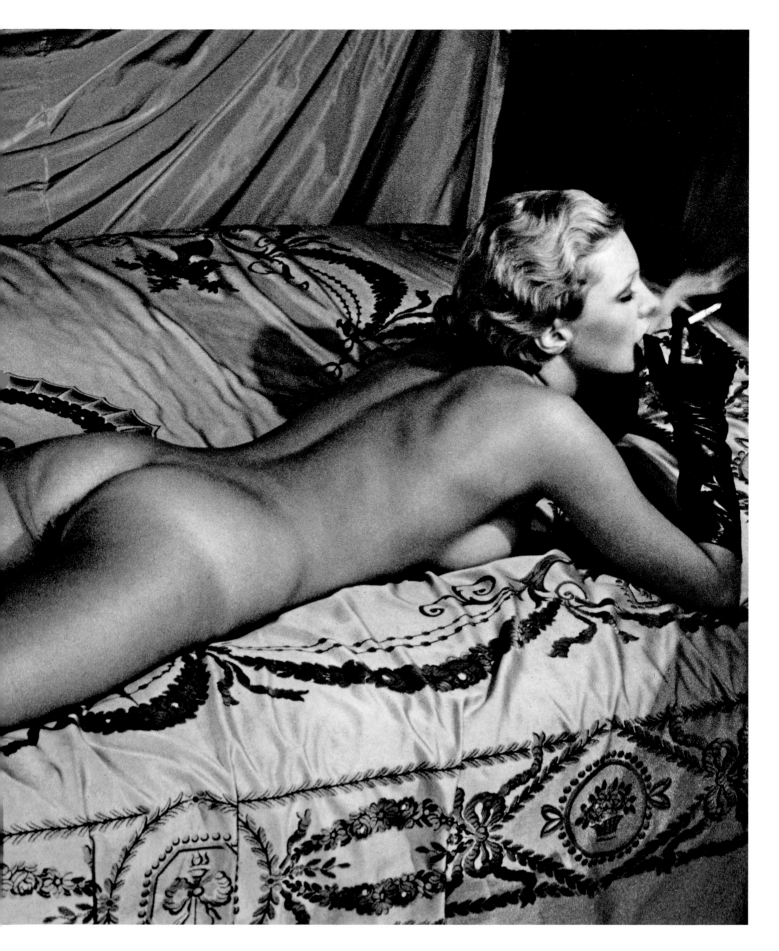

87 Roselyne on Napoleon's bed, Paris 1975

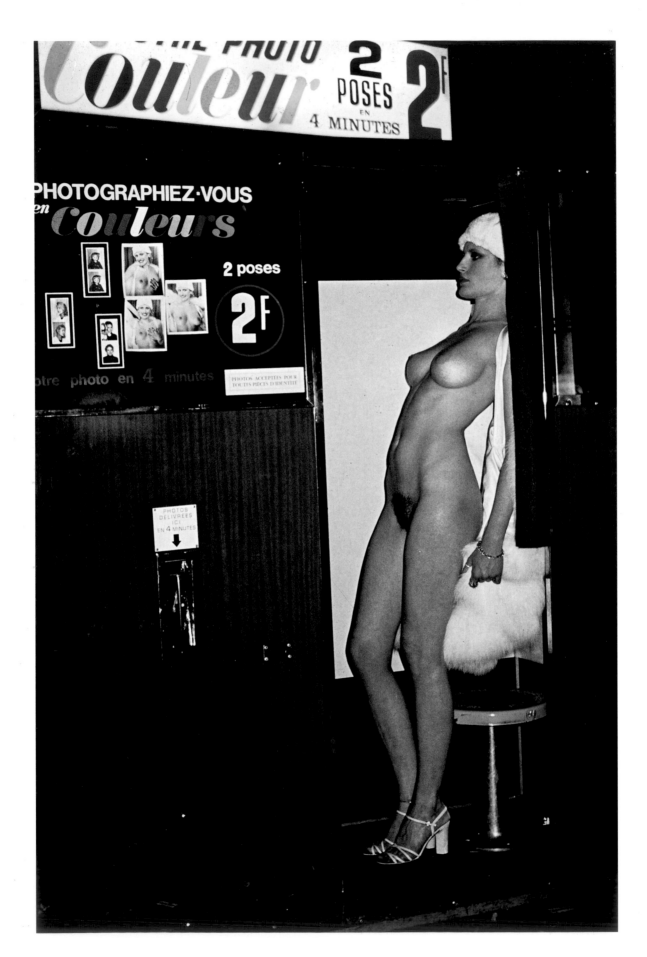

88 In a Photomaton booth, Paris 1974

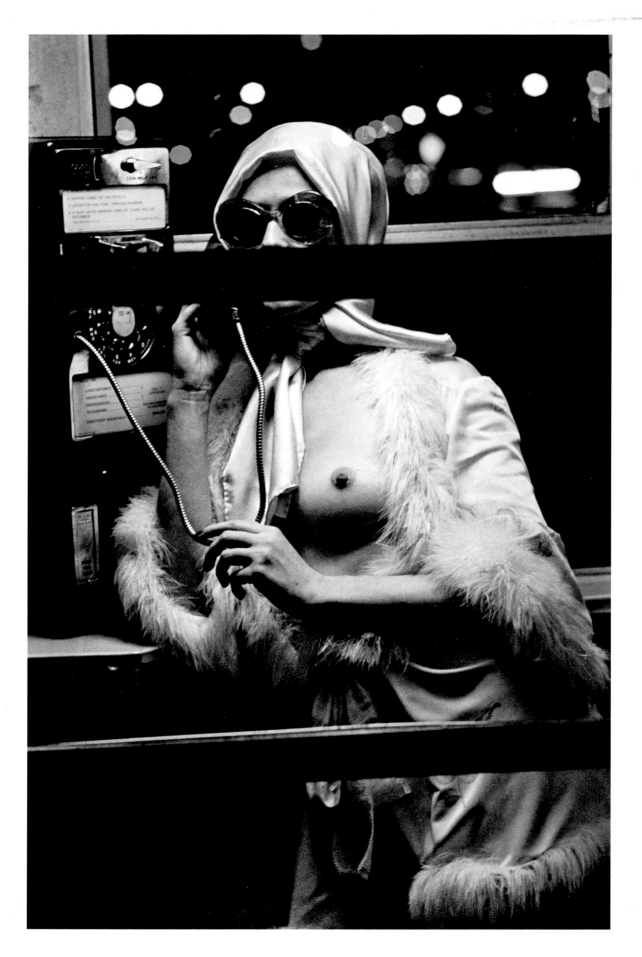

89 "Night Call". In a telephone booth, Paris 1974

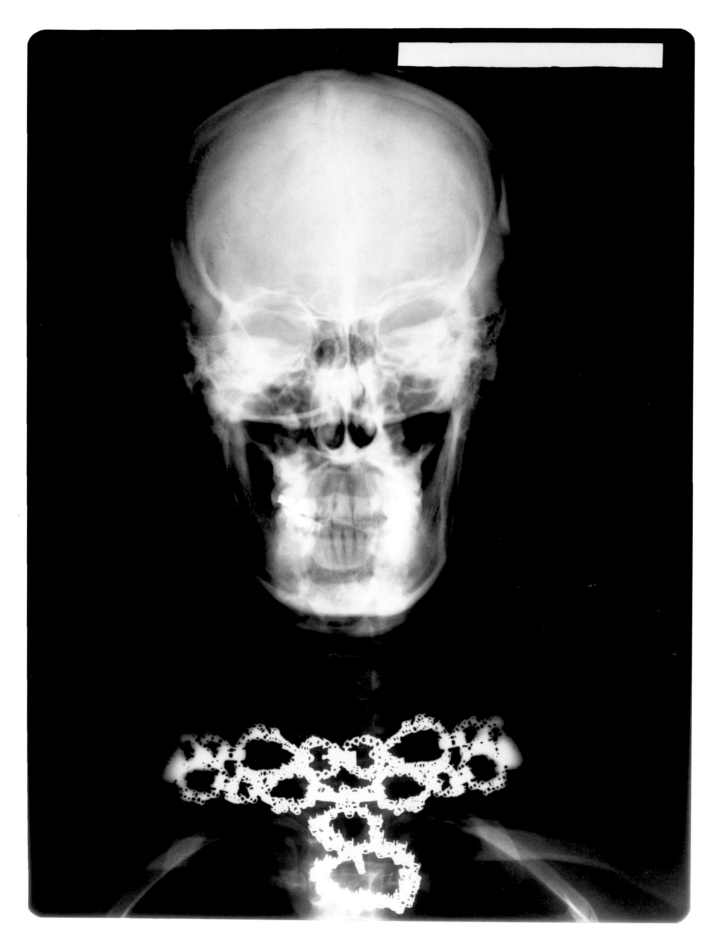

90 Skull and diamond necklace, Paris 1979 (Diamond necklace by Van Cleef & Arpel)

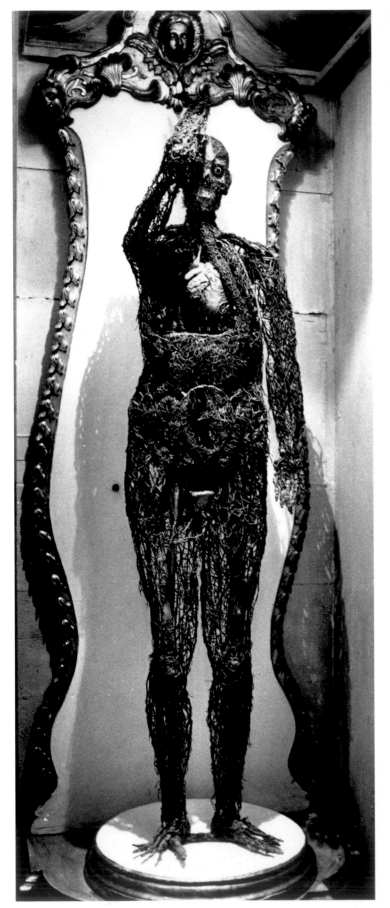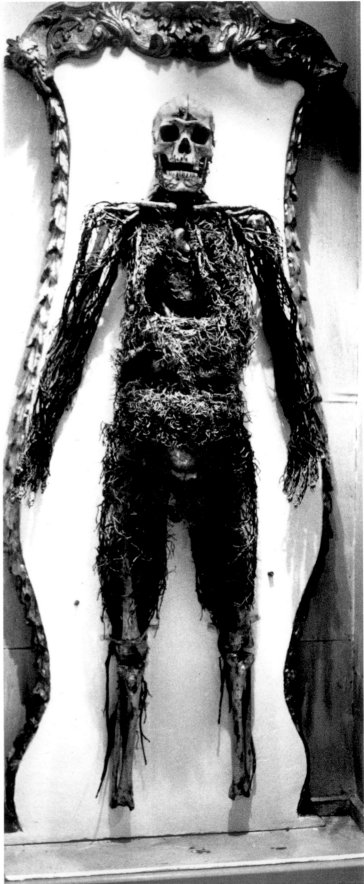

91 and 92 Victims of the Prince of Sansevero, Naples 1990

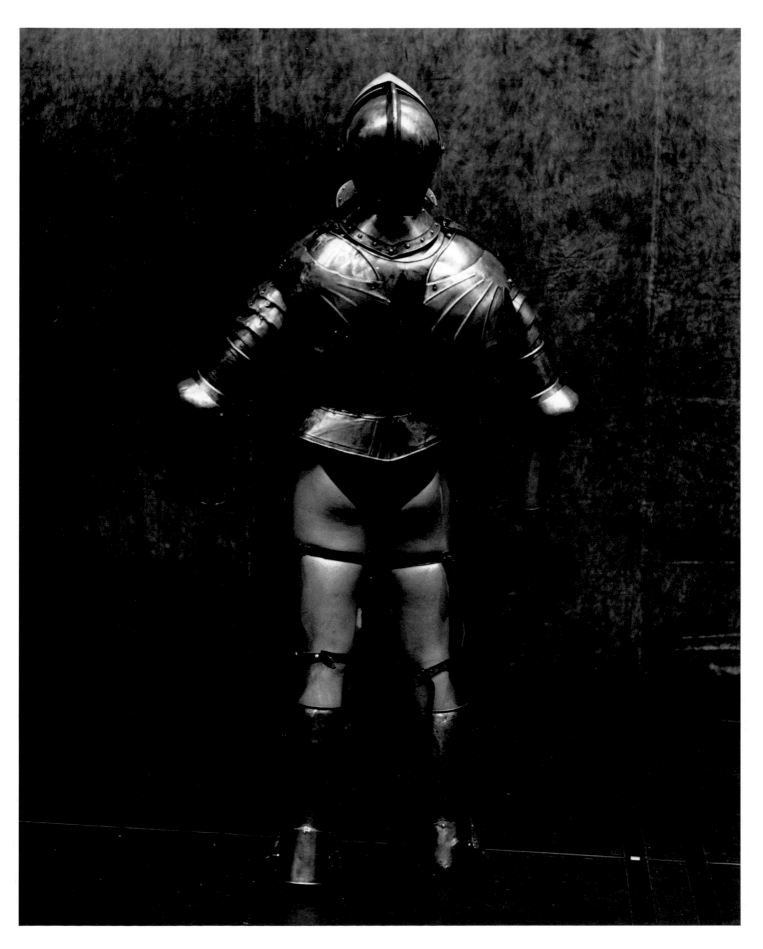

93 Jan Fabre Ballet, Frankfort 1989

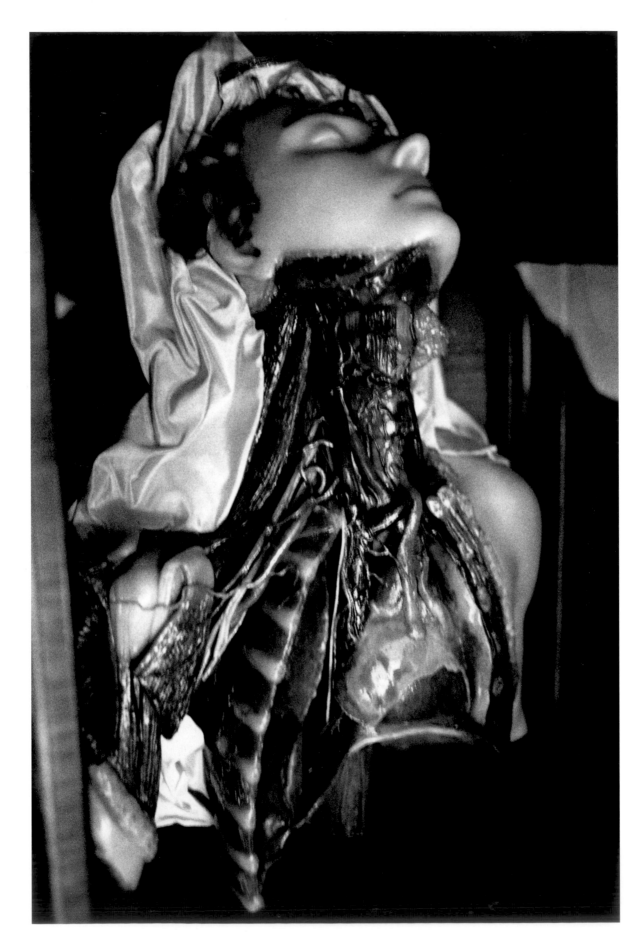

94 In Prof. Holubar's Josefinum I, Vienna 1992

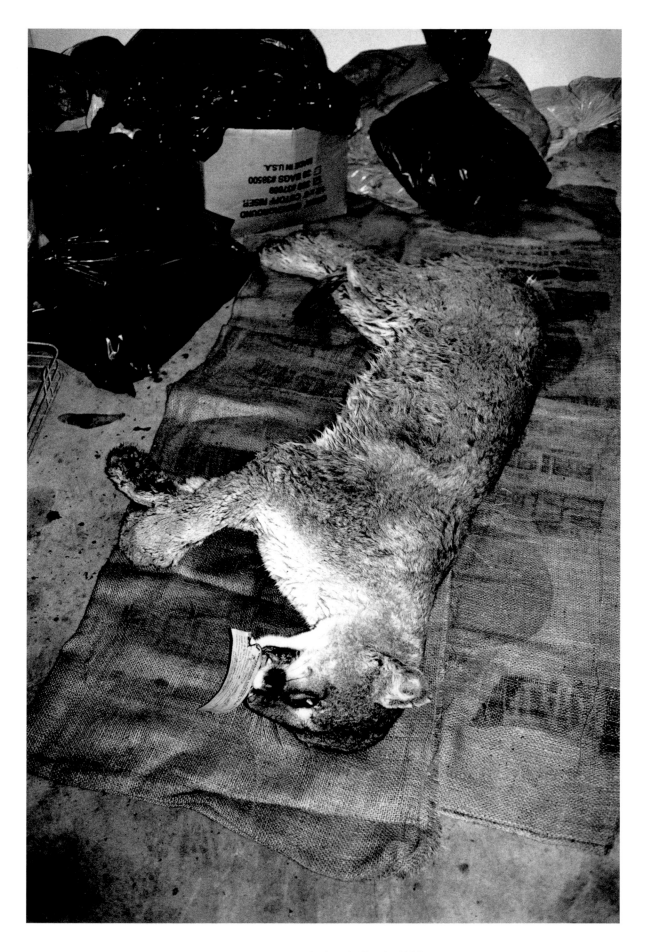

95 Dead mountain lion, California 1992

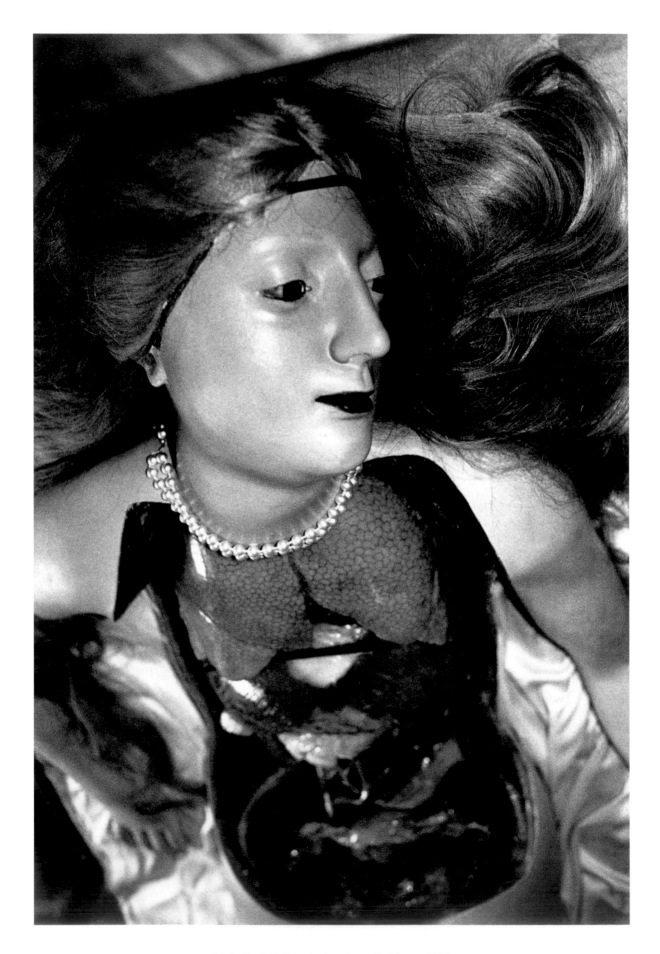

96 In Prof. Holubar's Josefinum II, Vienna 1992

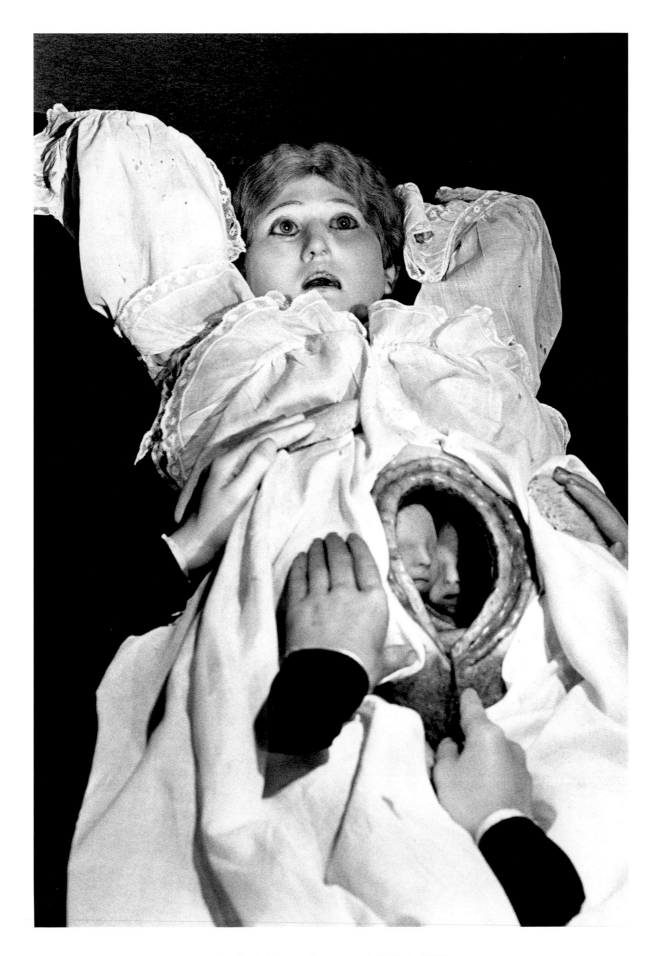

97 Dr. Spitzner – Caesarean birth, Paris 1980

98 The Cardinal's chamber, Villa Medici, Rome 1993

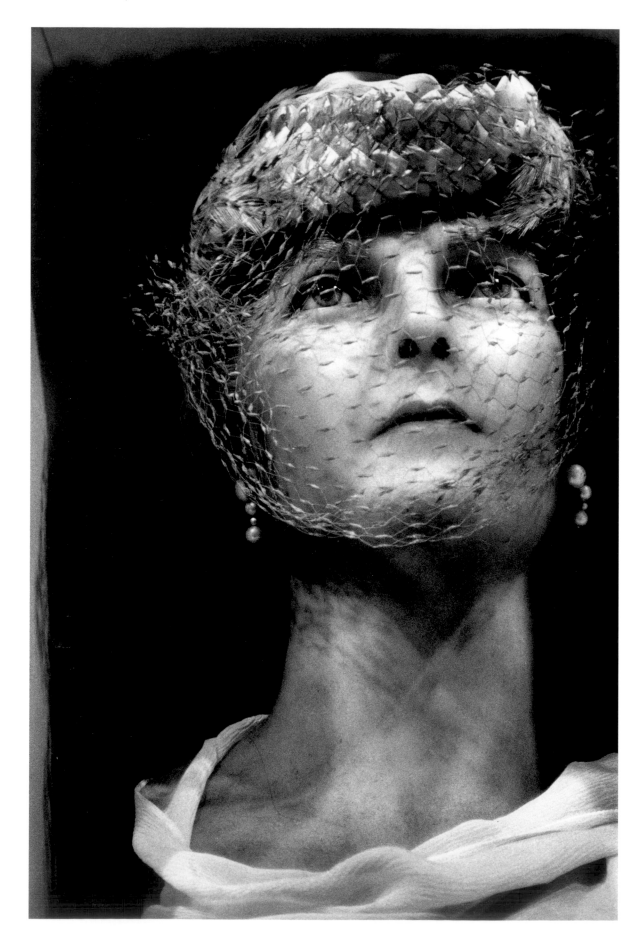

99 Woman's head, Paris 1993

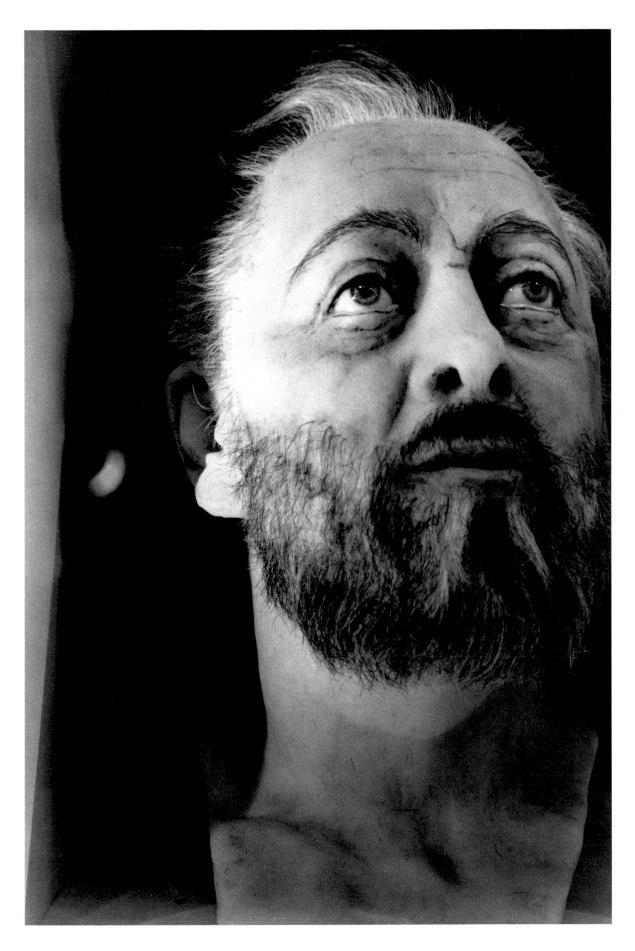

100 Man's head, Paris 1993

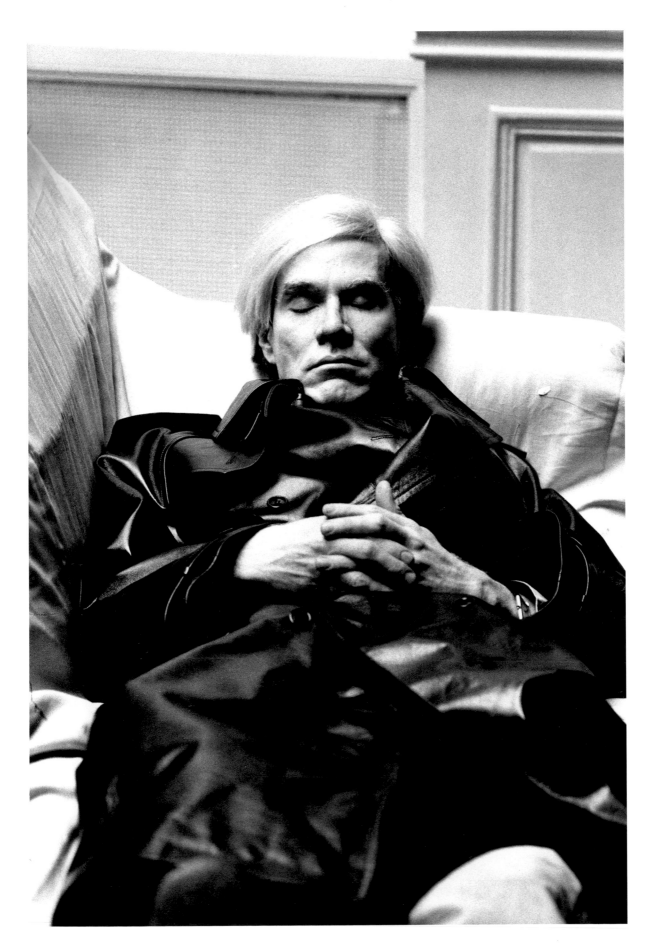

101 Andy Warhol, Paris 1974

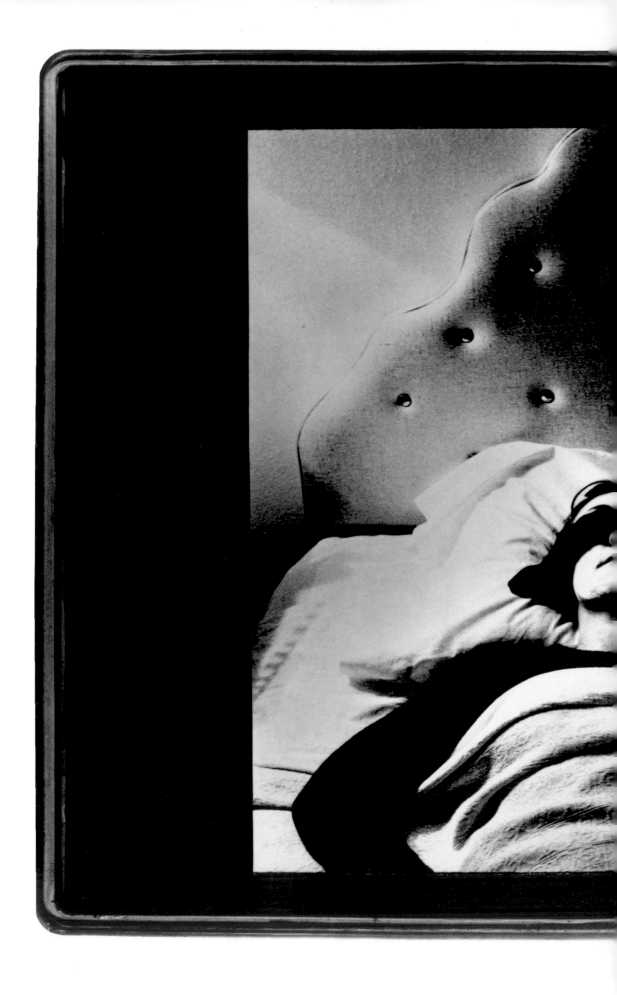

102 June resting, Hotel Volney, New York 1972

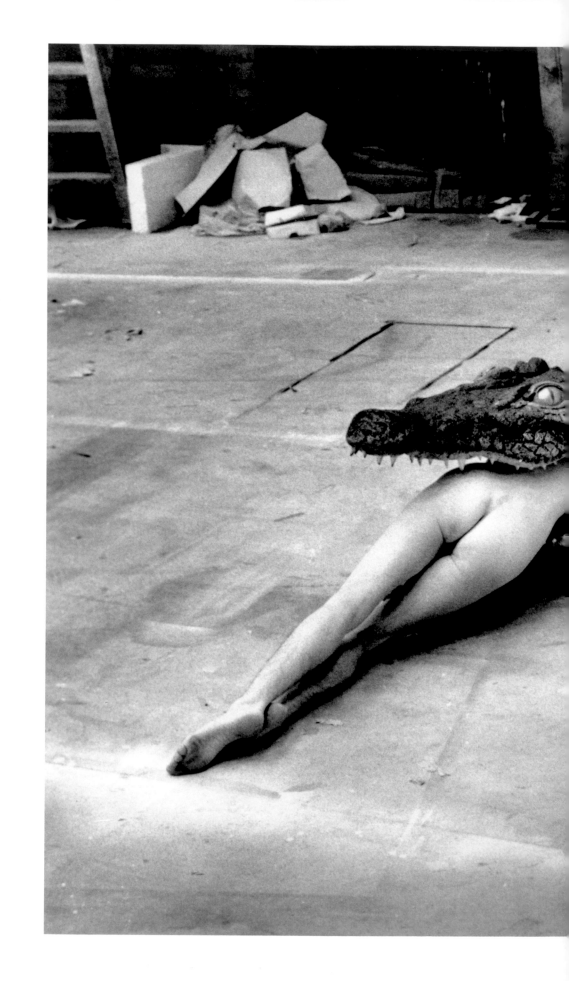

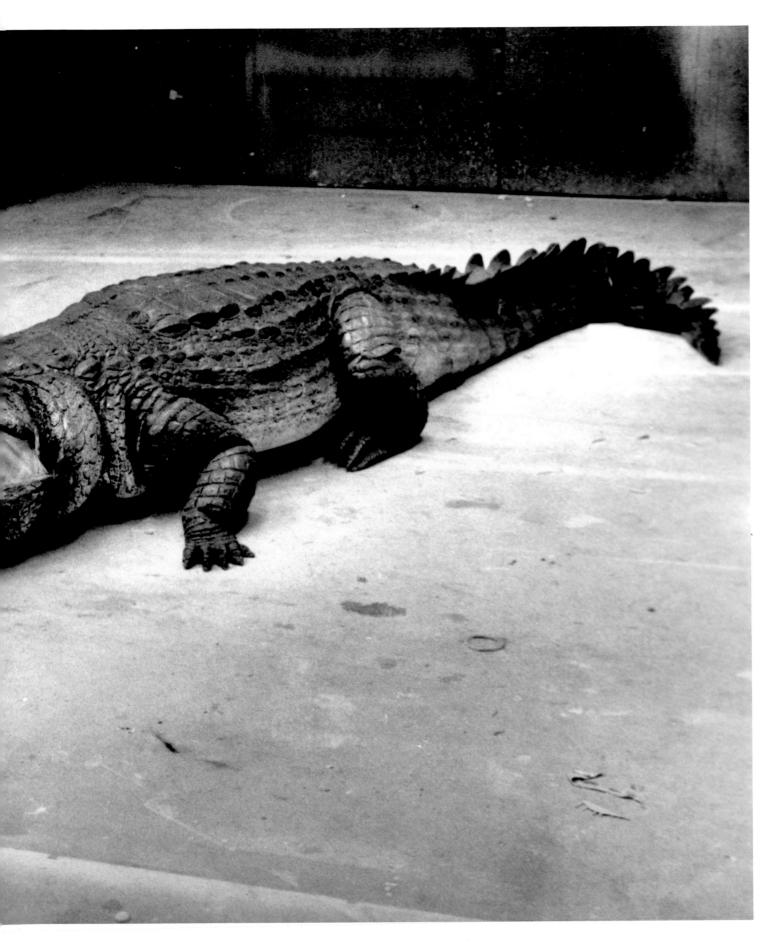

103 Crocodile eating ballerina, Wuppertal 1983 from a Pina Bausch ballet

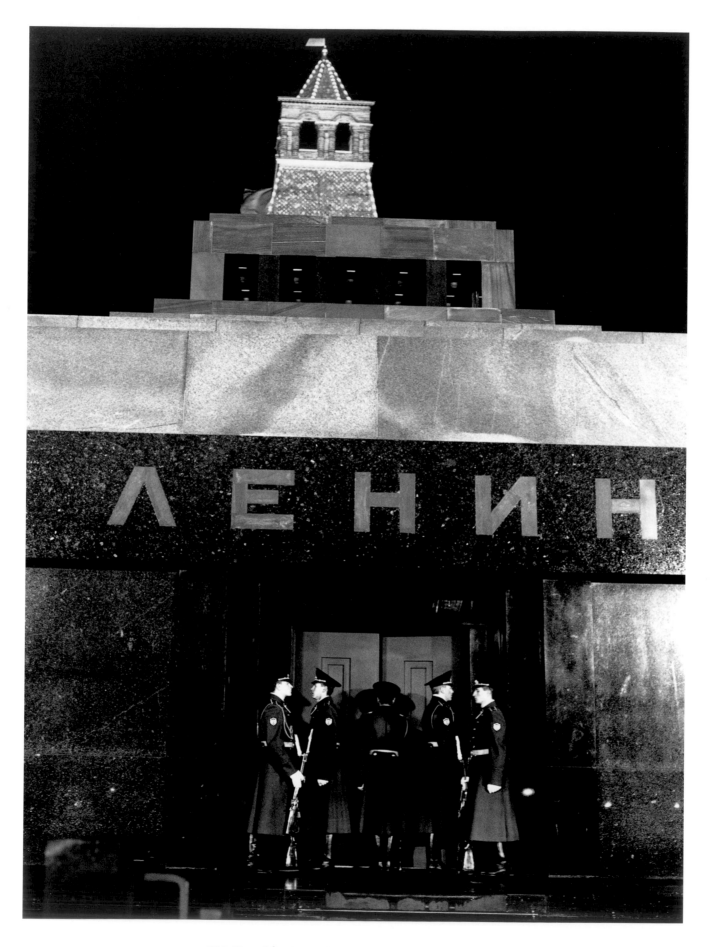

104 Changing of the guards, Lenin's tomb, Moscow 1989

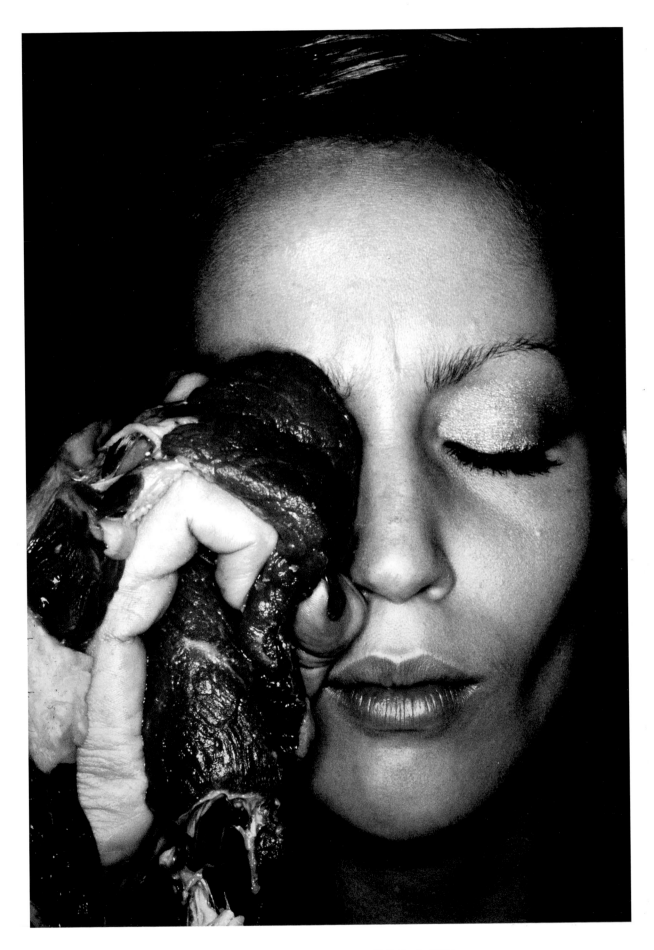

105 A cure for a black eye, Jerry Hall, Paris 1974

Biography

Born on 31 October 1920 in Berlin.

Australian citizenship.

At sixteen he starts an apprenticeship under the Berlin photographer
Yva, famous for her fashion, portrait and nude photography.

In 1957 he moves to Paris.

In the sixties and seventies, he provides regular contributions to the
French, American, Italian and English editions of *Vogue*, also for
Elle, Marie-Claire, Jardin des modes, U.S. *Playboy, Nova, Queen*,
and *Stern*.

Since 1981 a resident of Monte Carlo.

1975 First solo exhibition, Galerie Nikon, Paris.

1976 Prize of the Art Directors Club, Tokyo, for the best photography
of the year.

1977/78 Prize of the American Institute of Graphic Arts for his
first book, *White Women*.

1978/79 Gold Medal of the Art Directors Club, Germany, for the best
journalistic photograph.

1989 Named *Chevalier des Arts et des Lettres* by the French Minister
of Culture, Jack Lang.

Receives the "Photographers Award for Outstanding Achievements
and Contributions to Photography During the Sixties and Seventies"
from the Photographic Society of Japan.

The French Prime Minister, Jacques Chirac, presents him with the
"Grand Prix national de la ville de Paris".

1990 Presented the "Grand Prix national de la photographie"
by Jack Lang.

1991 "World Image Award" for the best portrait photograph,
New York.

1992 Awarded the *Grosses Bundesverdienstkreuz* by the Federal
Republic of Germany.

Named *Chevalier des Arts, Lettres et Science* by S.A.S. Princess
Caroline of Monaco.

Solo Exhibitions

1975	Galerie Nikon, Paris.
1976	Photographer's Gallery, London.
	Nicholas Wilder Gallery, Los Angeles.
1978	Marlborough Gallery, New York.
1979	American Center, Paris.
1980	G. Ray Hawkins Gallery, Los Angeles.
1981	Galerie Daniel Templon, Paris.
1982	Studio Marconi, Milan.
	Galerie Denise René – Hans Mayer, Düsseldorf.
	Marlborough Gallery, New York.
	Galerie Tanit, Munich.
	Galerie Photokina, Cologne.
1983	Gallery Asher-Faure, Los Angeles.
	"Big Nudes", G. Ray Hawkins Gallery, Los Angeles.
1984	Musée Chéret, Nice.
	Museo Palazzo Fortuny, Venice.
	"Private Property", G. Ray Hawkins Gallery, Los Angeles.
1984–85	"Retrospective", Musée d'art moderne, Paris.
1985	New York, G. Ray Hawkins Gallery, Los Angeles.
	"Retrospective", Museo dell' automobile, Turin.
1985–86	Galerie Artis, Monte Carlo.
1986	"Retrospective", Palais de l'Europe, Menton.
	"Retrospective", Foto Foundation, Amsterdam.
1987	"Retrospektive", Rheinisches Landesmuseum, Bonn.
	"Nus inédits", Galerie Daniel Templon, Paris.
	"Retrospective", Musée de Groningue, Groningen.
1988	"Retrospektive", Museum des 20. Jahrhunderts, Vienna.
	"Retrospektive", Forum Böttcherstrasse, Bremen.
	"New Nudes", Galerie Reckermann, Cologne.
	"Retrospektive", Berlinische Galerie/Martin-Gropius-Bau, Berlin.
	"New Nudes", Hamilton Gallery, London.
1988–89	"Nouvelles Images", Espace photographique de Paris Audiovisuel, Paris.
	"Portraits Retrospective", National Portrait Gallery, London.

1989	"Fashion Photographs & Portraits", Metropolitan Teien Art Museum, Tokyo.
	"Fashion Photographs & Portraits", Seibu Art Museum, Funabashi, Japan.
	"Helmut Newton, Nuevas Imagenes", Fundación Caja de Pensiones, Madrid.
	"Helmut Newton in Moscow", Puschkin Museum & Perwaia Galeria, Moscow.
	"Fashion Photographs & Portraits", Prefectural Museum of Art, Fukuoka, Japan.
	"New Images", Galleria d'arte moderna, Bologna.
1989–90	"New Images", Carlsberg Glyptothek Gallery, Kopenhagen.
1990	Kunstforum Galerie, Vienna.
	Hochschule für Graphik und Buchkunst, Leipzig.
	"Fashion Photography & Portraits", The Museum of Modern Art, Shiga, Japan.
1991	"Biennale", Lyons.
	Museum of Modern Art, Bratislava, Czechoslowakia.
	"Naked & Dressed", Hamilton Gallery, London.
1992	"Naked & Dressed in Hollywood", Pascal de Sarthe Gallery, Los Angeles.
	"Helmut Newton", Goro International Exhibition, Tokyo.
	"Archives de Nuit", Crédit Foncier de France, Head Office, Paris.
1993	"Helmut Newton", Carla Sozzani Gallery, Milan.
	Centre culturel française de Rome, Rome.
	"Archives de Nuit", Villa Medici, Rome.
1993–94	"Helmut Newton. Aus dem photographischen Werk", Deichtorhallen, Hamburg; Josef-Albers-Museum, Bottrop; Fotomuseum Winterthur, Winterthur; Castello di Rivoli, Turin.

Group Exhibitions

1975	Emily Lowe Gallery, New York: "Fashion Photography, Six Decades".
1977	International Museum of Photography, Rochester, N.Y.: "The History of Fashion Photography".
1978	Galerie Photokina, Cologne: "Fashion Photography".
1979	Galerie Zabriskie, Paris: "French Fashion".
1980	Galerie Zabriskie, Paris: "20/24 Polaroid".
	Centre Georges Pompidou, Paris: "Instantanés".
1981	Musée Rath, Geneva: "Aspects de l'art d'aujourd'hui, 1970–1980".
	G. Ray Hawkins Gallery, Los Angeles: "Hans Bellmer, Helmut Newton, Alice Springs".
1982	Musée Jacquemart-André, Paris, and Galerie Photokina, Cologne: "50 années de photographie de *Vogue* Paris".
1985	Victoria and Albert Museum, London: "Shots of Style".
1986	Palais de l'Europe, Menton: "La femme sur la plage".
1988	Musée de la Mode, Paris: "Splendeurs et misères du corps".
	Musée d'Art Moderne, Paris: "Splendeurs et misères du corps".
	Triennale Fribourg: "Splendeurs et misères du corps".
	Royal Academy of Arts, London: "The Art of Photography".
1989	Museum of Fine Arts, Houston: "The Art of Photography".
	Ministry of Culture of the Soviet Union, Moscow.
	Kunstforum, Vienna.
1991	Victoria and Albert Museum, London: "Appearances".
1993	Hôtel de la Monnaie, Paris: "Regards d'artistes sur la femme".
	Centre national de la photographie, Hôtel Salomon de Rothschild, Paris: "Vanities".

Public Collections

American Friends of the Israel Museum, Jerusalem
Baltimore Museum of Art, Maryland
Berlinische Galerie, Martin-Gropius-Bau, Berlin
Brandeis University, Waltham, Massachusetts
Bucknell University, Lewisburg, Pennsylvania
Chamber Opera Theatre, New York
College of the Holy Cross, Worcester, Massachusetts
College of William and Mary, Williamsburg, Virginia
Corcoran Gallery of Art, Washington, D.C.
Fashion Institute of Technology, New York
Fonds régional d'art contemporain, Bordeaux
Michigan University, Dearborn, Michigan
Michigan State University, East Lansing, Michigan
Musée d'art moderne, Saint-Etienne
Musée des Beaux-Arts, Jules Chéret, Nice
Musée départemental des Vosges, Epinal
Ohio Wesleyan University, Delaware, Ohio
Rheinisches Landesmuseum, Bonn
San Francisco Museum of Modern Art, California
State University of New York at Albany, New York
University of Pennsylvania, Philadelphia
University of Wisconsin, Milwaukee
Victoria and Albert Museum, London
Paris Audiovisuel, Ville de Paris
National Portrait Gallery, London
Haus für deutsche Geschichte, Berlin

Bibliography

Books and Exhibition Catalogues

1976 *White Women,* foreword by Philippe Garner, New York: Congreve;
 London: Quartet Books; Munich: Schirmer/Mosel; Paris: Filipacchi.

1978 *Sleepless Nights,* foreword by Edward Behr, New York: Congreve;
 London: Quartet Books; Munich: Schirmer/Mosel; Paris: Filipacchi.

1979 *24 Photo Lithos – Special Collection,* foreword by Brion Gysin,
 New York: Congreve; London: Quartet Books; Munich: Schirmer/Mosel;
 Paris: Filipacchi.

1981 *Big Nudes.* 1st edition, foreword by Bernard Lamarche-Vadel, English
 and French edition, Paris: Editions du Regard.

1982 *Helmut Newton – 47 Nudes,* foreword by Karl Lagerfeld, London:
 Thames & Hudson. (The original title *Big Nudes* was changed to
 47 Nudes for the English edition.)

1983 *White Women,* foreword by Philippe Garner, Japanese edition by
 Kodansha.

1984 *World without Men,* text by Helmut Newton, New York: Xavier Moreau.
 Helmut Newton – Portraits, foreword by Françoise Marquet, exhibition
 catalogue, Musée d'art moderne de la Ville de Paris.

1984–86 *Big Nudes,* 2nd and 3rd editions, text by Karl Lagerfeld, New York:
 Xavier Moreau.

1986 *Helmut Newton – Portraits,* exhibition catalogue, Foto Foundation,
 Amsterdam.
 Helmut Newton – Portraits, 1st edition, foreword by Carol Squires,
 New York: Pantheon; Paris: Nathan; Munich: Schirmer/Mosel; London:
 Quartet Books.

1987 *Helmut Newton's Illustrated No. 1 – Sex and Power.* New York:
 Xavier Moreau.
 Helmut Newton's Illustrated No. 2 – Pictures from an Exhibition,
 foreword by Helmut Newton, Munich: Schirmer/Mosel.

1987–90 *Big Nudes,* 4th, 5th and 6th editions, text by Karl Lagerfeld, Munich:
 Schirmer/Mosel.

1988	*Helmut Newton – Nouvelles Images*, text by Henry Chapier, Espace photographique de Paris, Paris Audiovisuel.
	Helmut Newton – Portraits, London: National Portrait Gallery; Munich: Schirmer/Mosel.
1989	*Helmut Newton – Portraits*, text by Klaus Honnef and Helmut Newton, exhibition catalogue, Metropolitan Teien Art Museum, Tokyo (includes: Ikuro Takano, "Of his negative sensuality").
	Helmut Newton – Nuevas Imagenes, exhibition catalogue, Fundación Caja de Pensiones, Madrid.
	Helmut Newton – Private Property, text by Marshall Blonsky, Munich: Schirmer/Mosel.
1990	*Das Glas im Kopf wird vom Glas*, text by Jan Fabre, 1st edition, Belgium: Imschoot Uitgevers, to accompany the performance "The Dance Sections" at the Théâtre de la Ville, Paris.
1991	*Helmut Newton – Sleepless Nights*, 2rd edition, Munich: Schirmer/Mosel.
	Helmut Newton's Illustrated No. 3 – I was there, 1st edition, foreword by Helmut Newton, Munich: Schirmer/Mosel.
1992	*Eroticism in the 20th Century,* exhibition catalogue, Tokyo and Fukuoka for GORO International, exhibition sponsored by the Goethe Institut, Tokyo, and The Photographic Society of Japan.
	Naked & Dressed in Hollywood, foreword by Jan von der Marck, curator of the Detroit Institute of Arts, exhibition catalogue, Pascal de Sarth Gallery, Los Angeles.
	Helmut Newton – White Women, 5th edition, Munich: Schirmer/Mosel.
	Helmut Newton – Pola-Woman, foreword by Helmut Newton, 1st edition, Munich: Schirmer/Mosel.
	Archives de Nuit, exhibition catalogue, foreword by José Alvarez, Crédit Foncier de France, Paris Head Office, Paris: Hazan Editions.
1993	*Regards d'artistes sur la femme*, exhibition catalogue, Hôtel Salomon de Rothschild, Centre nationale de la photographie, Paris.
1993–94	*Helmut Newton. Aus dem photographischen Werk*, edited by Zdenek Felis, with texts by Noemi Smolik and Urs Stahel, exhibition catalogue, Deichtorhallen Hamburg; Josef Albers Museum, Bottrop; Fotomuseum Winterthur; Castello di Rivoli, Turin.

Films on Helmut Newton

1978 *Helmut Newton*, television documentary by Michael White, Thames Television, London, 55 minutes.

1988 *Frames from the Edge*, television documentary by Adrian Maben, R. M. Productions. Video cassette in English and Spanish, 90 minutes. French and German versions are planned.

1992 *The Originals*, television documentary by Sleeping Giant Productions, 25 minutes.